THEN & NOW

KING OF PRUSSIA

Opposite: This photograph from the mid-1930s shows the King of Prussia Antique Shop and General Store, located at the intersection of Swedes Ford Road and Gulph Road. Built in the late 18th century, it was one of the three original buildings that made up the center of business and social activity that was King of Prussia. The gas pump, built by the owners of the King of Prussia Inn, replaced a hitching post that stood in the middle of the crossroad for many years. It became the subject of litigation in 1935 when it was alleged that the filling station was erected on public property. The suit was finally settled, and the pump remained for many years.

THEN & NOW

KING OF PRUSSIA

J. Michael Morrison

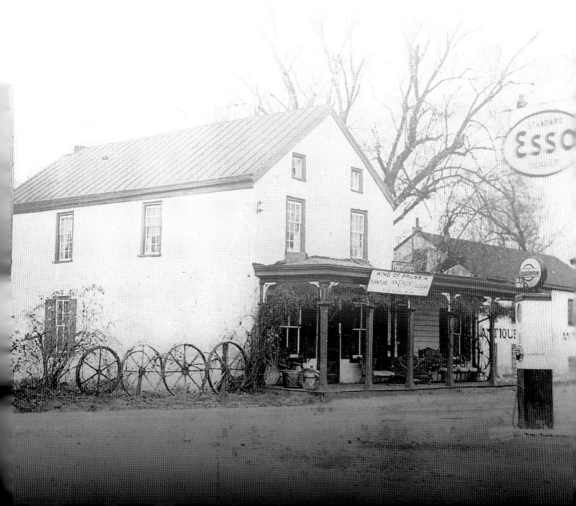

Dedicated to Doris Freeman, and her tireless efforts in maintaining the high standards of historic preservation throughout the community. Because of her dedication on behalf of the Upper Merion Township Public Library and the Upper Merion Senior Services Center, a new awareness of our past history is being cultivated in the hearts and minds of our citizens.

Copyright © 2007 by J. Michael Morrison
ISBN 978-0-7385-4933-0

Library of Congress control number: 2006931597

Published by Arcadia Publishing
Charleston SC, Chicago IL, Portsmouth NH, San Francisco CA

Printed in the United States of America

For all general information contact Arcadia Publishing at:
Telephone 843-853-2070
Fax 843-853-0044
E-mail sales@arcadiapublishing.com
For customer service and orders:
Toll-Free 1-888-313-2665

Visit us on the Internet at www.arcadiapublishing.com

On the front cover: These views of the busy intersection of U.S. 202 and Gulph Road clearly illustrate an area forced to change with the times. Arguably the largest shopping mall in the country was built on a pasture, and roads had to be widened to accommodate an increasing flow of traffic. Old buildings needed to be razed, and service stations gave way to gas pumps with mini-marts. The Philadelphia and Western High-Speed Line (P&W) was built in 1906 and required several aqueducts be built along its route from Upper Darby to Norristown. (Vintage image courtesy of Lockheed Martin; contemporary photograph by J. Michael Morrison.)

On the back cover: This view shows a crew hard at work creating the roadbed for the trolley to pass through Gulph Mills over Gulph Creek, along what is now Trinity Lane. (Courtesy of Emma Carson.)

CONTENTS

ACKNOWLEDGMENTS

Without the help of so very many dedicated individuals, this book would still be just a dream. Special thanks to Francis X. Luther, B.S., M.A., and retired educator, for not only writing the foreword to my first book, *King of Prussia*, in the Images of America series, but for his constant encouragement, thoughts, and ideas. Frank's commitment has touched many on our community, and I applaud his tireless efforts. Special thanks also to Jean S. Olexy, B.A., M.E., and retired educator, for continuing to be a source of great inspiration to me.

Thanks to David Broida, director of Upper Merion Park and Recreation for his help in providing many of the historic photographs in this collection, and for his friendship over the years. Thanks to Vincent Martino Jr., author of *Phoenixville*, in both the Images of America and the Then & Now series, as well as *Northern Chester County*, in the Postcard History series, for helping to keep me focused, and for providing many of the historic photographs in this book. Thanks to my wife, Diane; my sister Patty; and my mother, Joan, for their constant encouragement. Thanks to John W. Cooley for taking me flying so I could get some great aerial shots.

Thanks to Joseph Kucharik for keeping me informed about changes in the hospitality industry. Thanks to Emma Carson, Bob Lee, George and William Spragg, and the countless others who have kept in touch since my last book and have shown great patience if I don't return their phone calls or e-mails right away. They provided so many wonderful historic photographs for me to use in this book.

Finally, my very special thanks are extended to Bob Krutsick and the members of the Upper Merion Park and Historic Foundation. This group is truly our last hope for historic preservation in King of Prussia. Thank you for picking up the torch and carrying it proudly!

FOREWORD

When Michael Morrison asked me to write the foreword to his new book, I felt honored and a bit overwhelmed. I didn't know where to start. As a retired high school English teacher, I looked back over my 32 years of teaching, remembering many outstanding students who have excelled in academic, professional, and humanistic endeavors. They are legion. However, one student with an inquiring mind, an appreciation of his heritage, and a historic perspective has remained in my memory these many years. That student is Michael Morrison.

In the autumn of 2005, I was volunteering as a helper in the Roberts Elementary School library. My grandson is a student in this excellent school. I considered it a privilege to be of some help to Maggie Caverly, the outstanding media specialist/school librarian at Roberts School. I heard a voice calling my name. It was the lovely Patty Morrison Volpi, who reacquainted me with her brother's whereabouts and his activities. I was delighted to learn that Michael had published his first book, *King of Prussia*, in the Images of America series; I was even more delighted to subsequently meet with Michael after so many years had intervened. I was proud that I had been Michael's teacher and been part of his intellectual growth.

Since leaving Upper Merion High School, as a graduate of the class of 1970, Michael has accomplished much. After earning his degree at Eastern University, he has followed his love of history in restoring local historic sites, working to preserve those places of history that are sometimes forgotten and often endangered through development and commercialism. These tasks have not been easy or without "sweat equity." Whether tramping through ancient cemeteries, charting and photographing the ruins of old buildings, or sorting through files of the township library, Michael has put forth Herculean efforts in preserving and recording elusive, fast-disappearing artifacts of our historic township.

A superb first publication must have a sequel. Michael has followed his first book, documenting the history of King of Prussia with his second publication, in the Then & Now series. The quintessential English and history student, Michael has remembered Shakespeare's admonition that "the past is prologue to the future." By doing so he has preserved our precious heritage for our children and for all who remember things "the way they were."

—Jean S. Olexy, B.A., M.E., and retired educator

INTRODUCTION

After my first book, *King of Prussia*, in the Images of America series was published in 2005, I was met with a reoccurring and very curious comment. "So, where exactly was the town of King of Prussia?" was a comment I became quite familiar with. I soon realized that the rapid growth of the town was also the cause of its demise.

I set out to see what I could do about telling the story of where the town was and why it had changed so completely from a sleepy hamlet established in 1713 to a thriving business environment hosting over 10 million visitors a year.

I contacted Upper Merion Township, where the town of King of Prussia is located, and suggested that we run a companion show to their very successful series *Remember When* on the government access channel. We would call it *Remember Where*, and through the use of old photographs and on-location shots, we could tell the story of where our town was and why it changed so dramatically. When my idea was rejected, I set out to try to tell the story that needed to be told, but this time on paper.

Here then, is the story of a location so ideal that it was quickly and completely swallowed up by the very force it spawned—progress. I have drawn upon the area known as greater King of Prussia for this book, using the unofficial name of the boundaries of the municipality of Upper Merion Township.

All of the contemporary images in this book are photographs I have taken. Those wishing to contact me to offer corrections or just to share a story may do so through my Web site, www.historicreeseville.com.

Partly in protest, and partly as a sad political commentary, this sign was recently erected in the town of Byers, in Chester County, Pennsylvania. It was meant to draw attention to the rapid growth that was quickly beginning to smother this quaint little town, not unlike what befell King of Prussia several decades ago.

THE CHANGING FACE OF KING OF PRUSSIA

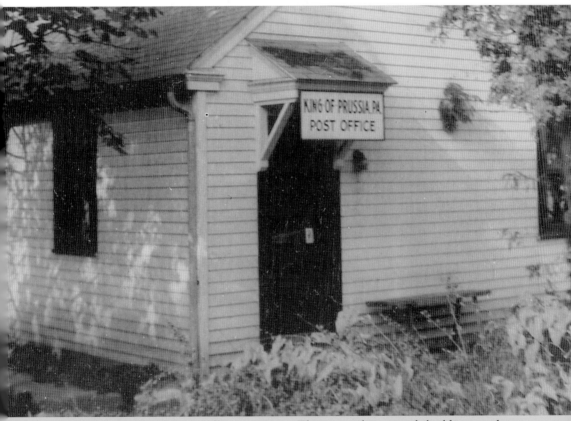

Imagine this tiny post office serving the estimated 18,511 residents (2000 census) of King of Prussia today. When this photograph was taken in the early 1940s, mail was dispersed from this little building located on the southbound side of U.S. 202, now covered by asphalt as the parking lot of the King of Prussia Plaza.

This was the second building used as a postal facility, and mail arrived daily by train and had to be collected at the Chester Valley Station across the street. Later when the rail line was closed, mail was delivered to post offices along U.S. 202 by car from Bridgeport to Exton. (Historic image courtesy of Arthur Cummins.)

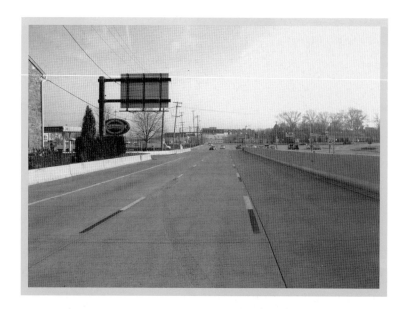

Nothing illustrates the dramatic changes to the little town of King of Prussia better than this pair of photographs. King of Prussia was established in 1713 and soon became an important town. A one-day ride from Philadelphia, it was often a staging area for those traveling west on the Swedes Ford Road (now U.S. 202). The Gulph Road that intersected it allowed for travel from the Old Lancaster Road (U.S. 30) to Reading. This early view from 1905 looking northbound is a vivid contrast to what can (or cannot) be seen today.

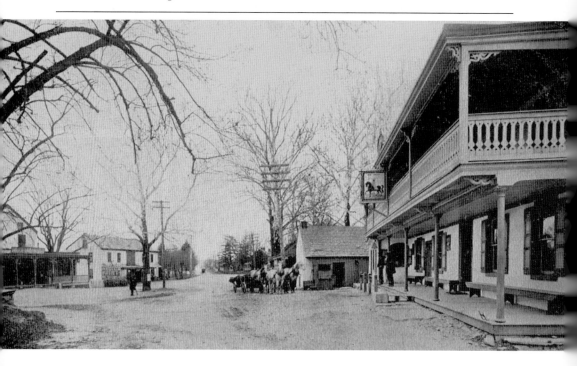

THE CHANGING FACE OF KING OF PRUSSIA

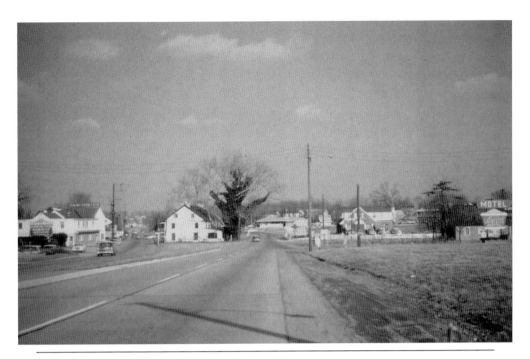

The first blow to the demise of the little town came in 1953, when the King of Prussia Inn was isolated between two lanes of U.S. 202. This early photograph taken in the late 1950s illustrates how the inn was rendered virtually useless. This practice of skirting historic structures was abandoned by planners in the late 20th century, as highways are now rerouted in order to preserve historic sites. Further expansion of the highway in 2000 necessitated the removal of the building entirely, as seen in the later photograph looking northbound on U.S. 202. (Historic image courtesy of David Broida.)

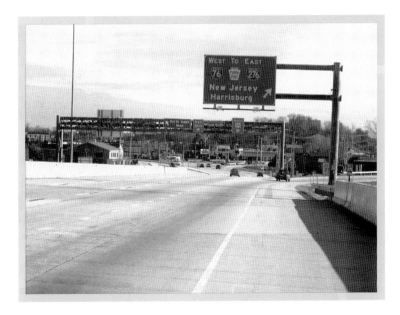

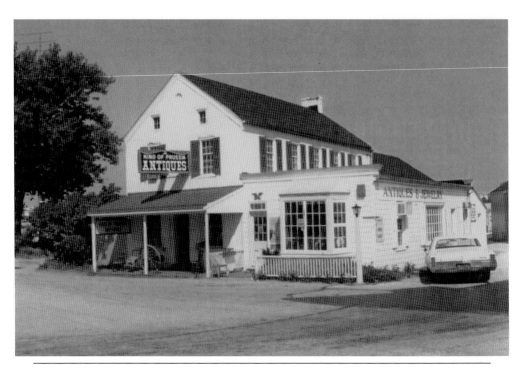

The first building to fall in the name of progress was the King of Prussia Antique Shop and General Store, owned by the author's grandparents. Built in the late 18th century, it served the town as the first post office and general store. It was located adjacent to the King of Prussia Inn, on the southbound side of U.S. 202. The building was demolished in 1986, and a Lukoil gas station is located there today. The roadway in the foreground of the early photograph is the original routing of Gulph Road.

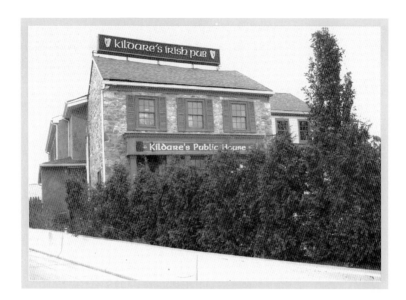

The Peacock Gardens, seen here in this early postcard from the mid-1950s shows one of the earliest structures in King of Prussia. Built in 1747, it was once the home of Dr. Henry Dewitt Pauling and remained in his family until the beginning of the 19th century. Later incarnations included the Peacock Inn, Mr. Ron's Public House, and Pizzeria Uno. Today it still serves the community as a fine restaurant known as Kildare's Irish Pub. This building is the only structure that remains as part of the original town of King of Prussia. (Historic image courtesy of Vincent Martino Jr.)

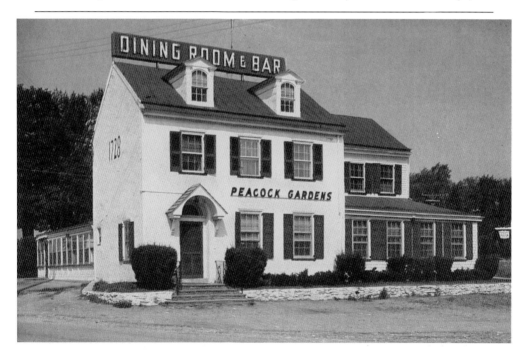

This view looks northbound from the southbound lanes of U.S. 202. Dubbed Swedes Ford Road as early as 1718, it ran from Bridgeport to points south and west, intersecting with the Old Lancaster Road. It was also an important route for trade goods from the port of Wilmington, Delaware, making their way north to be put on barges in Bridgeport for their journey to Philadelphia. The road later became State Route 122 and received its designation as U.S. 202 in 1935. Locals refer to it as DeKalb Pike. The early photograph was taken in 1976, prior to the widening of the road in 2000. The isolated King of Prussia Inn is partially visible on the right, and it is clear to see why it became necessary to move it.

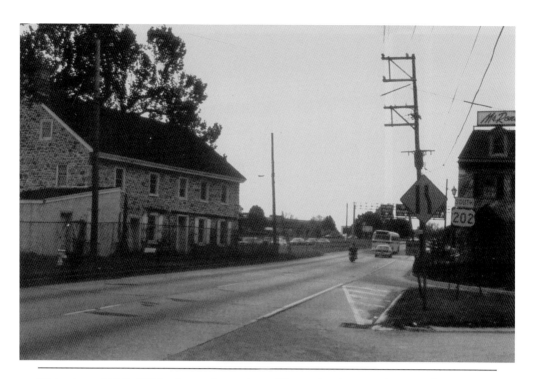

This view of U.S. 202 looks south on the original intersection of Swedes Ford Road and Gulph Road, which constituted the original center of King of Prussia. Gulph Road was laid out in 1713 and ran from the Old Lancaster Road to the many mill facilities in Gulph Mills. It was later extended to King of Prussia and became a favorite route of trade from Philadelphia.

The early photograph was taken in 1976 and illustrates the need for the changes that would inevitably come. The central location of the original town located at the crossroad of two major routes was a formula for rapid growth. A small portion of the original route of Gulph Road still remains and can be seen off to the right.

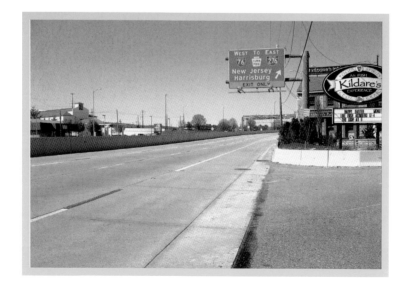

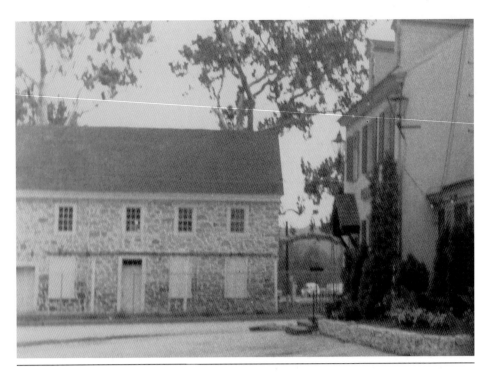

The King of Prussia Inn is seen in this early photograph from 1976, in its original location directly across the road from the Peacock Inn. Expansion of the roadway necessitated the moving of the inn in August 2000. This was a monumental project, considering the structure was nearly 300 years old and weighed in at over 580 tons! Al Paschall and members of Pennsylvania's historic preservation and transportation groups worked together to raise funds, and the plan was set in motion. The entire process of moving this structure one half mile to its new home was accomplished in one day.

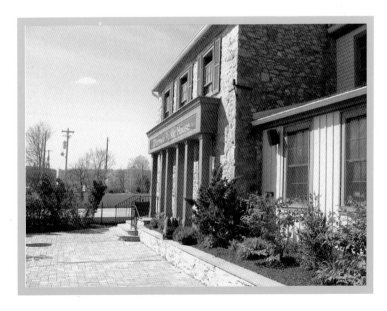

THE CHANGING FACE OF KING OF PRUSSIA

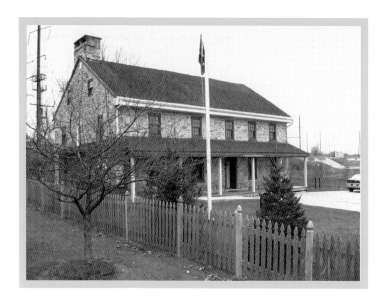

The earliest reference to the King of Prussia Inn can be found in a tavern license issued to Philip Rees in 1762. It achieved prominence during the Revolutionary War as a place where spies gathered from both sides of the conflict. By 1900, when this early photograph was taken, King of Prussia was a well-established town. When the expansion of U.S. 202 forced its closure on June 28, 1952, it had been in constant operation for nearly 200 years. Today the inn serves as the headquarters for the Schuylkill Alliance, an amalgamation of chambers of commerce from Fort Washington to Valley Forge, and from Collegeville to Conshohocken. (Historic image courtesy of the Historical Society of Montgomery County.)

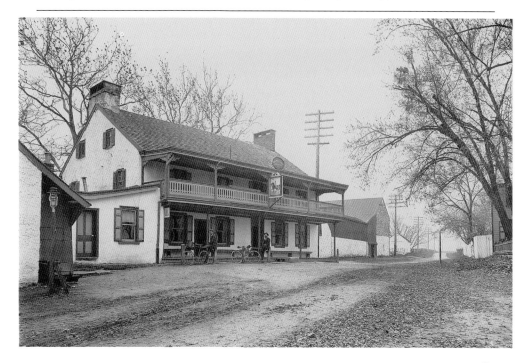

After its closing in 1952, the King of Prussia Inn sat idle and empty for almost 50 years. This early photograph taken in 1959, as part of the Historic American Buildings Survey sponsored by the National Park Service, shows the old stairway in the center hall. The stairway was probably not original because of changes to the floor framing, and in fact, the entire interior still had the modifications made to it when the Waters family began running it in 1920. During restoration, a search for answers as to how the interior appeared in Colonial times was undertaken in order to give the inn an authentic yet functional look inside. (Historic image courtesy of the Library of Congress.)

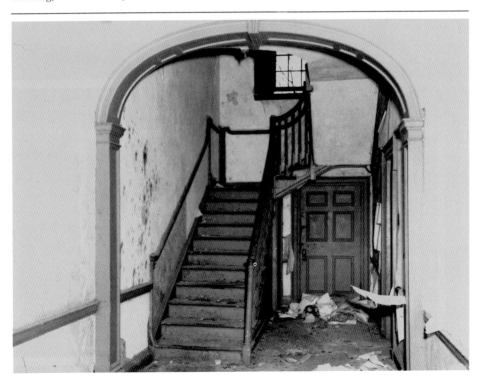

THE CHANGING FACE OF KING OF PRUSSIA

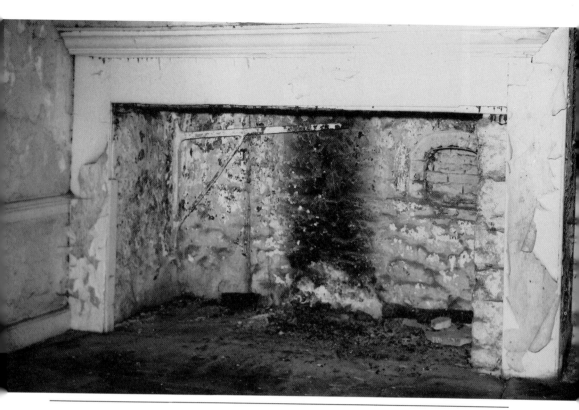

The walk-in fireplace, complete with crane and bake oven, was the center of activity in an early inn. No menus were offered, and travelers ate what was prepared each day. The fare usually consisted of a hearty stew of local game meat and vegetables that would simmer all day, and usually terminated with a choice of fresh baked pies. It is rumored that the Marquis de Lafayette was inducted into the Masonic lodge of George Washington in front of this fireplace. Today the partition wall has been removed, and the room serves as a meeting place for members of the chamber of commerce. (Historic image courtesy of the Library of Congress.)

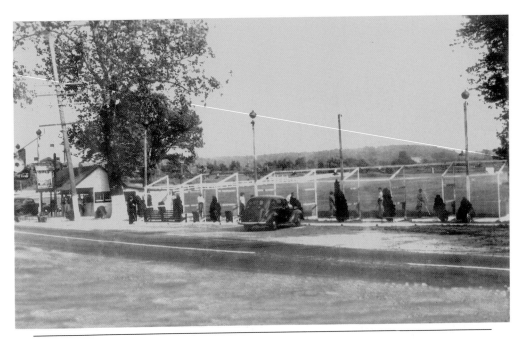

The King of Prussia Driving Range was located at the intersection of U.S. 202 and Gulph Road, where the Howard Johnson's Motor Lodge once stood, and is now occupied by the Inn at King of Prussia. John A Crockett owned the property and lived across Gulph Road where Chili's and Wawa are now located. The Wood family ran the business until 1952, when the construction of Schuylkill Expressway and the Pennsylvania Turnpike forced its closure. The Woods reopened their golf center in Norristown in 1960 on Germantown Pike, and it is still a thriving business today. (Historic image courtesy of the Wood family.)

The Howard Johnson's Motor Lodge was built soon after the closing of the King of Prussia Driving Range. It was a modern facility with 126 rooms, each with a 21-inch television, air conditioning, and a private patio. The swimming pool can also be seen on the left. The latest incarnation to occupy the spot is the Inn at King of Prussia, a Best Western facility. Although given a contemporary facelift, the buildings that house the guest rooms are original.

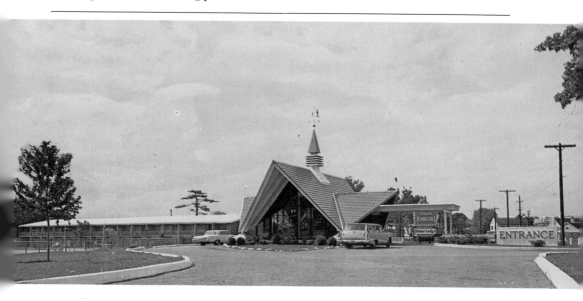

With the completion of the Schuylkill Expressway and the Pennsylvania Turnpike in the early 1950s, King of Prussia began to experience a rapid growth in population, as people could now live in the suburbs and work in the city. That growth in population led in turn to a growth in business opportunity. Weary travelers had many choices of places to stay. The George Washington Motor Lodge boasted 300 luxury suites, each with television, air conditioning, and hi-fi. Indoor and outdoor pools, a putting green, a Horn and Hardart restaurant, and a banquet facility capable of accommodating 1,000 people rounded out this early resort motel.

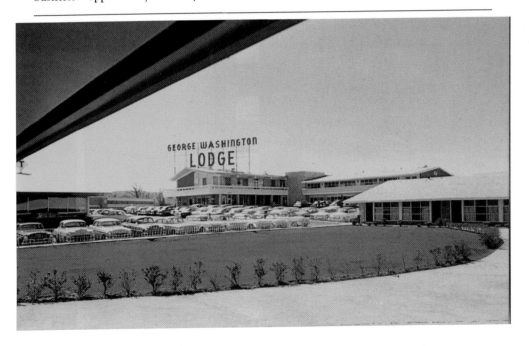

THE CHANGING FACE OF KING OF PRUSSIA

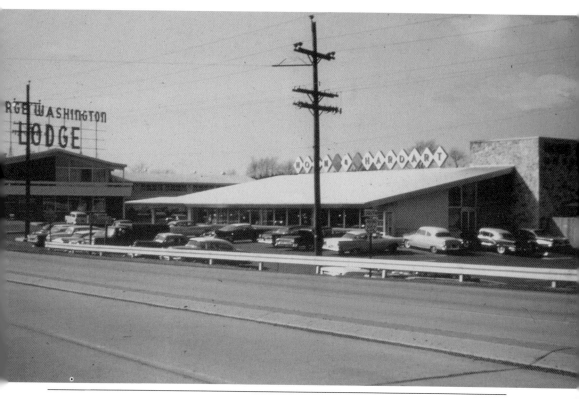

It is often said that location is everything, and nowhere is that phrase more truly spoken than in the case of King of Prussia. As major highways converge, business opportunities flourish. Occupying the spot where the George Washington Motor Lodge and Horn and Hardart once stood is a very successful Home Depot. Visible from many directions, it is not only an excellent location but a destination as well.

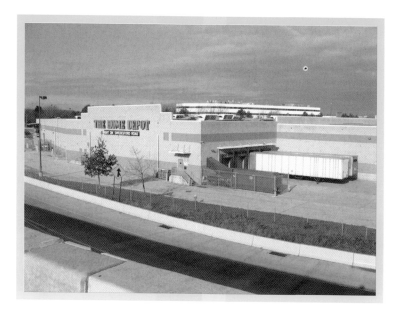

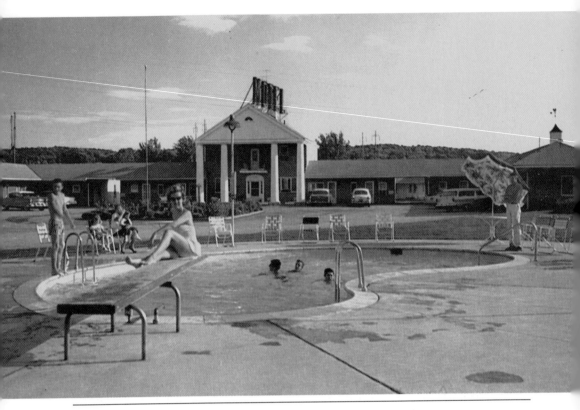

America took to the roads in 1952 with the opening of the Interstate Highway System, and King of Prussia was ready for them. The General Lafayette Motel emerged as the earliest traveler's oasis in the area. Strategically located on U.S. 202 northbound, it was an inviting stop, especially with its beautiful swimming pool right out front. The name was changed in the mid-1960s to the King of Prussia Motor Inn, and an annex was added to serve the needs of additional travelers and truck drivers carrying freight. Its proximity to the exit ramps of both the Pennsylvania Turnpike and the Schuylkill Expressway made it the perfect first stop.

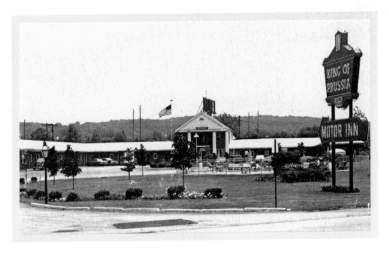

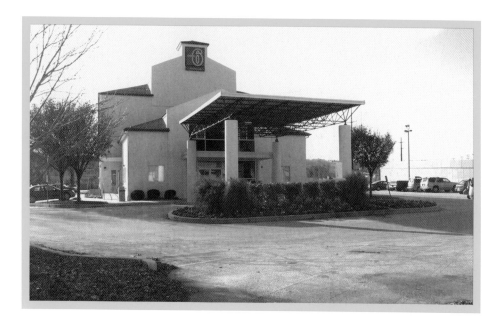

As the 20th century drew to a close, the urge to modernize and keep pace with the large hotels built in the 1970s caused a major renovation to the property. The once-expansive General Lafayette Motel now had close neighbors and was forced into consolidation. Seen here as the Budget Lodge, the only thing still recognizable from the original is the swimming pool. A Motel 6 now occupies the spot that has been offering weary motorists shelter for the night for over 50 years, albeit now without the swimming pool. (Budget Lodge photograph courtesy of Vincent Martino Jr.)

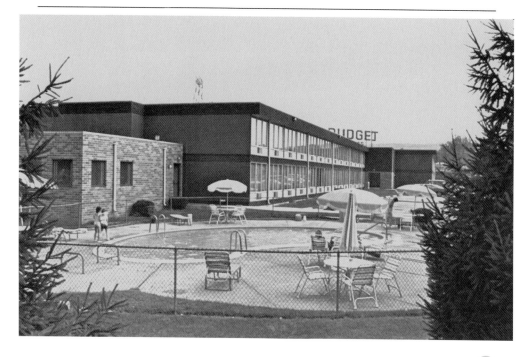

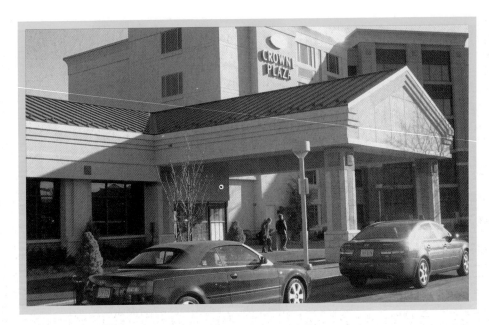

Opening in February 1969, the Holiday Inn would emerge as one of the premier facilities in the area. Located on Goddard Boulevard, its location made it easily accessible to visitors from the General Electric Space Technology Center on the hill, and of course the King of Prussia Plaza for shopping. Goddard Boulevard would be renamed Mall Boulevard; the plaza would add the court to become the largest shopping center in the country; GE would become Lockheed Martin; and the hotel would close its doors in June 2003, emerging in September 2004 after extensive renovations as the Crowne Plaza, the luxury brand of Holiday Inn.

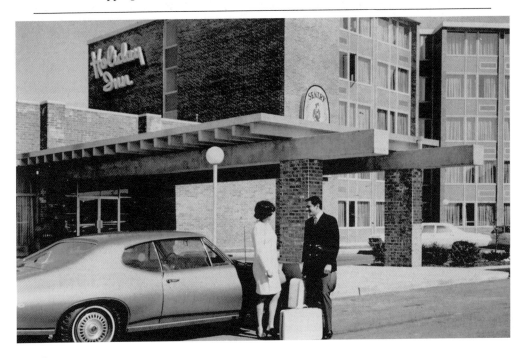

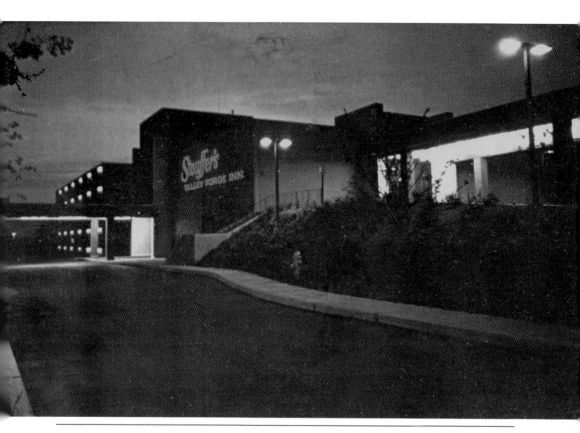

What is in a name? Stouffer's Valley Forge Inn was built in the early 1970s to capitalize on the rich convention and business activity in the area, and the potentially abundant business from the bicentennial of 1976. It was a quietly successful venture, and the hotel enjoyed its share of the lucrative trade. The Sheraton brand shifted from its former location around 2001, and the Park Ridge property is still highly regarded as a good place to stay in the area.

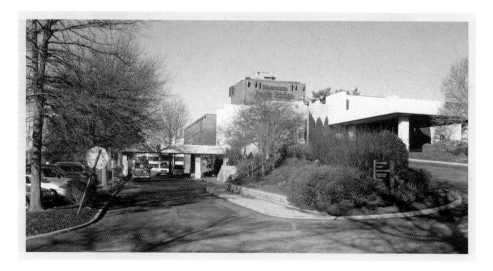

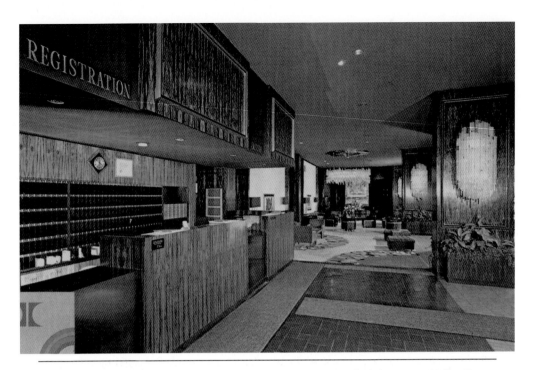

The Valley Forge Hilton is the only hotel in the area that at the time of this writing has never undergone a franchise change. The earliest of the major hotels to be built in the area, it has survived for over 35 years under the same ownership. The last day for the Hilton will be January 17, 2007, at which time it will become a privately owned hotel called the Inn at Valley Forge. The Magic Twanger was the first nightclub in the area, located on the lower level. The lobby area seen here, although fully renovated, still retains its open-air design. Plans for further renovations are in the works as the franchise changes. (Historic image courtesy of Vincent Martino Jr.)

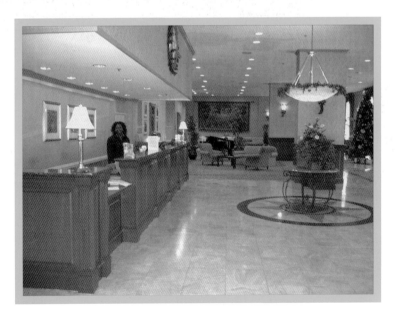

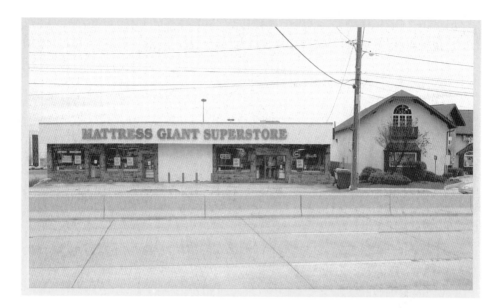

Highways brought people to King of Prussia, and people brought businesses. In 1954, a group of merchants opened King of Prussia's first shopping center. It was to become known as the forerunner of more elaborate shopping experiences to come. Located here were Morris Weisbaum's Drug Store and Soda Fountain, Robert E. Lee Hardware, Eddie Knasiak's Barber Shop, Joseph's Hair Styling, and William E. Wills Real Estate. The building still stands today as a single mattress outlet, with the partitions removed that once separated the stores. (Historic image courtesy of Herbert and Stanley Weisbaum.)

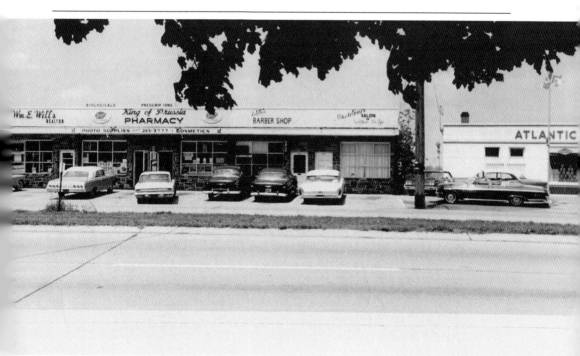

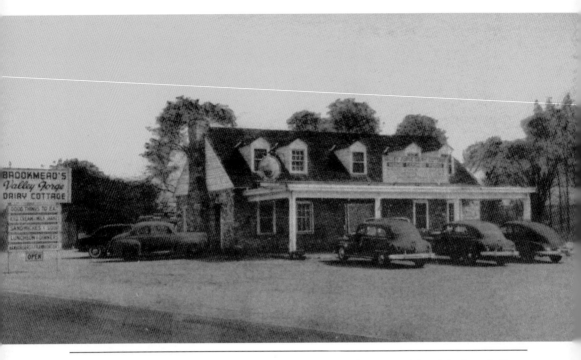

This building, located just northwest of town at the intersection of Gulph Road and Guthrie Road, has been serving as a restaurant ever since it was built. Brookmead Farm was located on Walker Road in Tredyffrin Township and served as quarters for General Pulaski during the Revolutionary War. Maplecroft Farm was located where the court and plaza at King of Prussia now stand. The Wilson family ran Maplecroft Farm for many years, eventually selling the name to a company in Phoenixville. (Image courtesy of Vincent Martino Jr.)

THE CHANGING FACE OF KING OF PRUSSIA

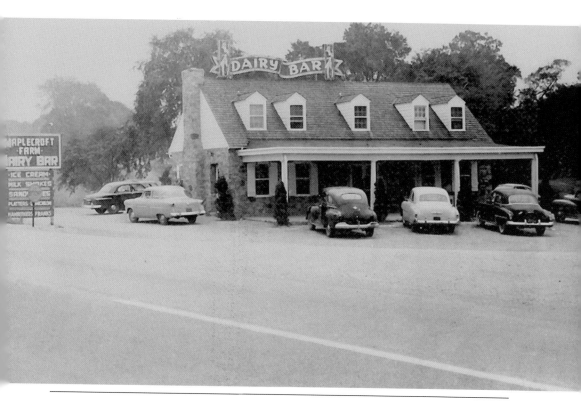

The building was also a dairy bar known as the Betsy Ross in the early 1960s, and later incarnations included the Sting, the Baron's Inn, and now Creed's. The location of the building on Gulph Road, the main access to Valley Forge Park, made it a convenient stop for those coming or going. It has barely survived the construction of both the Pennsylvania Turnpike and U.S. 422, not to mention the rerouting of County Line Road. (Historic image courtesy of Peter C. Brown.)

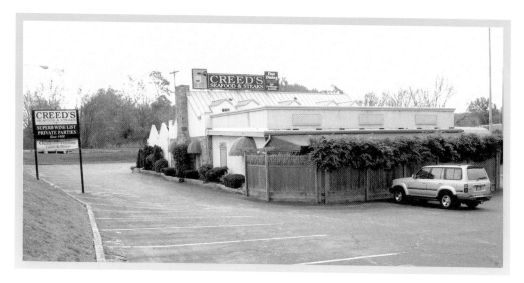

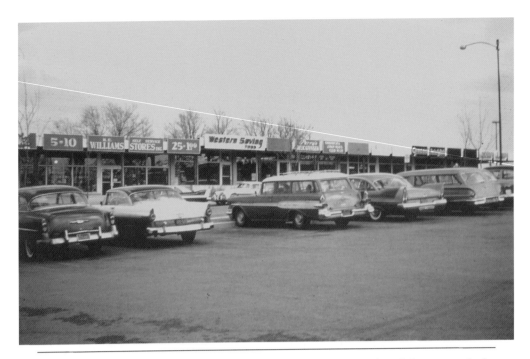

Two years after the arrival of the first shopping center, the second emerged a little farther north on U.S. 202. Bigger and better, the Valley Forge Shopping Center became the heart of King of Prussia's retail business. The A&P, King of Prussia's first supermarket, was located here, with Food Fair joining as co-anchor a few years later. Children would flock to see Santa Claus arrive by helicopter and greet them in his own gingerbread house, and the center was often visited by local television personalities as well. The King Theatre, the King of Prussia Lanes, Perry's Deli, Pat's Barber Shop, the Inn, and Donutland all made their homes here. Today it still serves as a thriving retail center for those who do not care to brave the traffic of the larger malls. (Historic image courtesy of David Broida.)

The China Garden was King of Prussia's first Chinese restaurant, located at the Valley Forge Shopping Center at the corner of U.S. 202 and Town Center Road. It was one of the first restaurants to be located in the shopping center when it opened, and remained there until the mid-1990s. As the original center of town became clogged with traffic, residents came to know the Valley Forge Shopping Center as the new heart of town. (Historic image courtesy Vincent Martino Jr.)

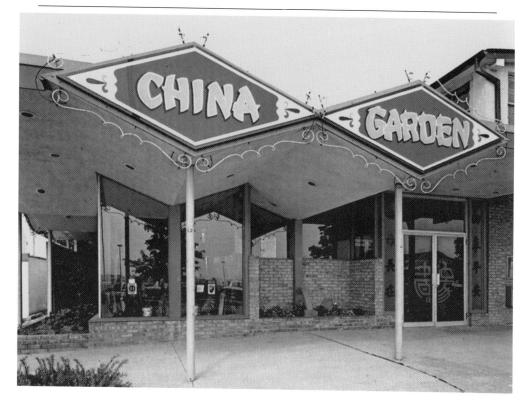

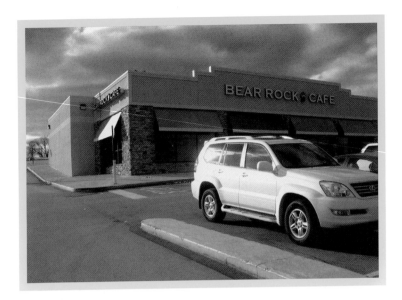

Further northbound on U.S. 202 and still within the confines of the Valley Forge Shopping Center is another prime restaurant location. Beck's on the Boulevard was located here, followed by the Lighthouse Restaurant in the early 1970s. Pizza Hut followed the Lighthouse and probably lasted the longest. The Bear Rock Cafe is a recent addition. (Historic image courtesy David Broida.)

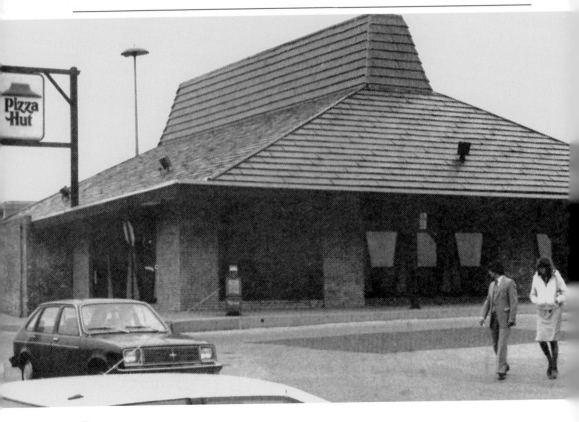

THE CHANGING FACE OF KING OF PRUSSIA

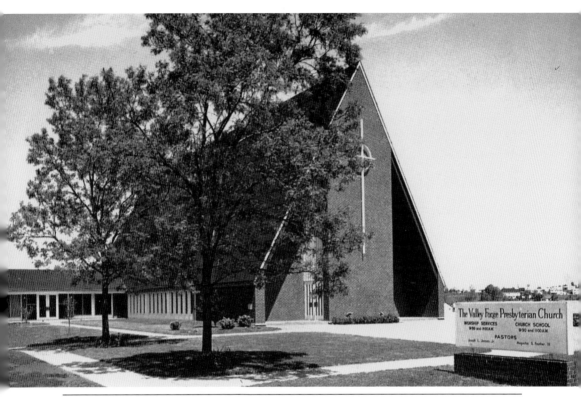

The more things change, the more others remain the same. The Valley Forge Presbyterian Church has been serving the King of Prussia community for over 50 years. Located on Township Line Road, just a block away from the Valley Forge Shopping Center, it was built during a period of growth in the Candlebrook section of the community in an area once known as Red Hill. Aside from the age of the foliage and an addition on the left, the facade remains as it did originally.

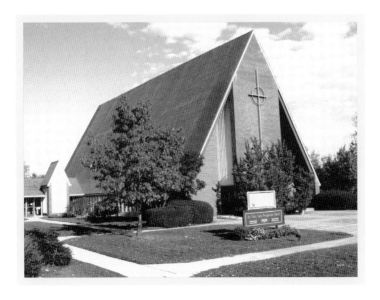

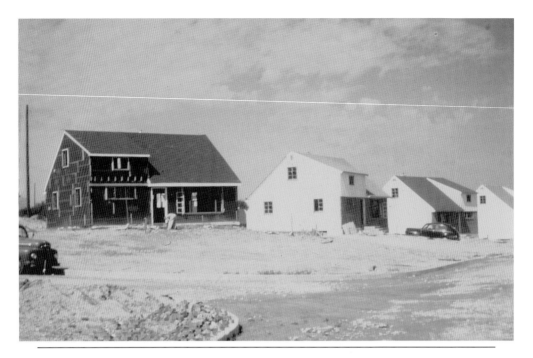

In 1952, the Schuylkill Expressway linked the Pennsylvania Turnpike with Philadelphia. A housing boom soon followed, and neighborhoods like Brandywine Village, Valley Forge Homes, Washington Park, Cinnamon Hill, Candlebrook, Hidden Valley, Sweetbriar, Lowell Hills, Belmont Terrace, and others virtually sprang up overnight. This view of a property at the corner of Prince Frederick Street and Stonybrook Road is located in the Candlebrook section of King of Prussia. (Historic image courtesy of David Broida.)

Another view from Prince Frederick Street in the Candlebrook development shows just how much the neighborhoods have matured since they were created over 50 years ago. Note the recent sewer excavation in the street. By 1958, the influx of residents was so great that the King of Prussia Post Office was forced to extend its boundaries to include the whole township, a job that was shared prior to that time by Wayne, Bridgeport, and others. (Historic image courtesy of David Broida.)

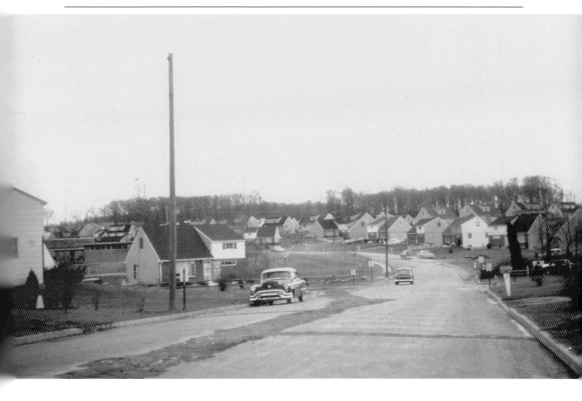

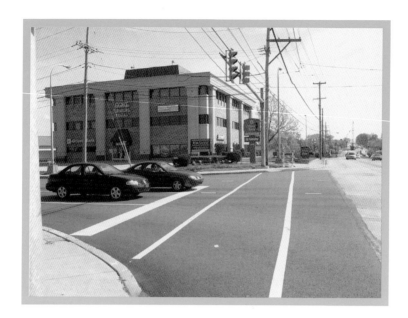

The Stewart Fund Hall can be seen in the foreground of this early photograph, with the Union schoolhouse off to the right. Built in 1879, the Stewart Fund Hall served the community for over 90 years as a grade school, a meeting house for the grange, a literary society, a building and loan association, a township office, a police station, a polling place, and a place for students to take exams. It was torn down in 1970 and replaced by a bank and office building.

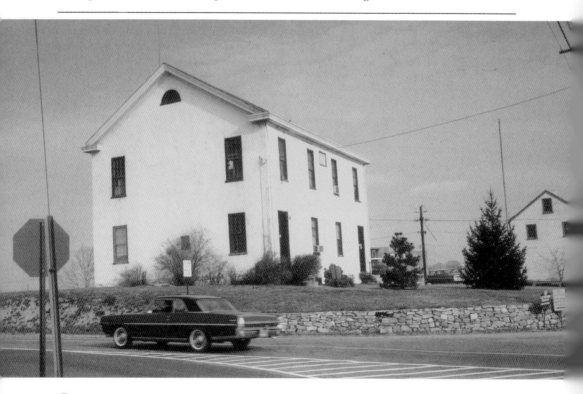

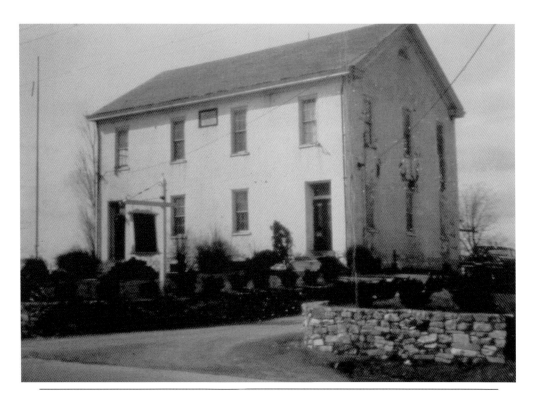

The Union schoolhouse, built in 1810, also served as the schoolmaster's quarters. This central location to the majority of the farms in the area was convenient for students and ended the practice of the schoolmaster having to travel from farm to farm. The location proved fatal, as the widening of the intersection at Allendale Road and U.S. 202 necessitated its removal in 1970 along with the Stewart Fund Hall, seen here. (Historic image courtesy of David Broida.)

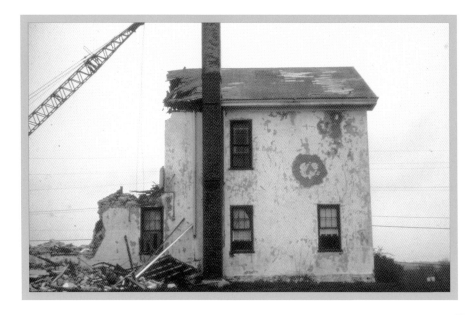

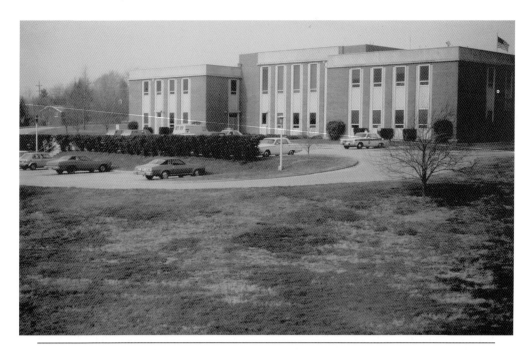

The facilities at the Stewart Fund Hall were outgrown, and the Upper Merion Township Municipal Building was built on the Hampton Farm, located at the corner of Henderson Road and Valley Forge Road. The building was dedicated on November 23, 1968, and has been the seat of government and the home of the Upper Merion Township Public Library ever since. An expansion was recently completed, and the facade was updated. (Historic image courtesy of David Broida.)

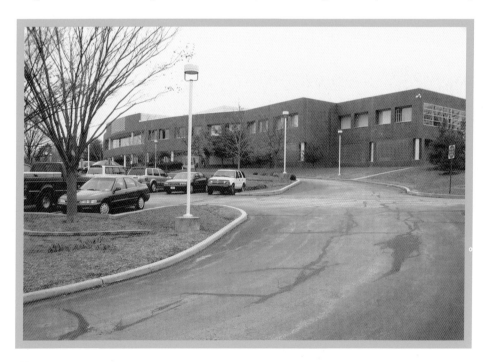

THE CHANGING FACE OF KING OF PRUSSIA

King of Prussia no longer has a Main Street, a place for the public to gather and share stories and ideas. Fortunately, a park was created behind the Upper Merion Township Municipal Building, which addresses that purpose well. The park serves as the center of activity in the township, including Fourth of July fireworks, the wildly popular King of Prussia Folk Music Summer Concert series "Concert under the Stars," Earth Day and Arbor Day observances, and many other planned functions under the able leadership of David Broida. (Historic image courtesy of David Broida.)

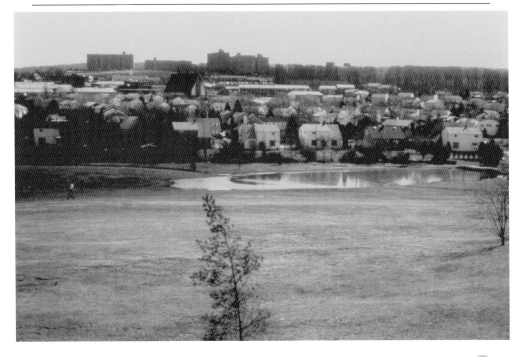

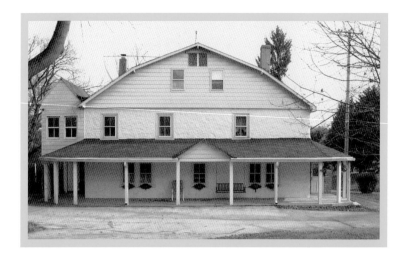

Alvernia Loughin poses in front of the family farmhouse on Valley Forge Road in this early photograph from April 1955. The author believes that the original two-room home, typical of southeastern Pennsylvania Welsh construction, dates from 1725 to 1750. Several additions have obscured the original home from view, and at one time, two separate families lived there. The Loughin's have owned the home for over 100 years, and its current owners, Brad Davis and Patricia Loughin Davis, plan to restore the home and live there. (Historic image courtesy of the Loughin family.)

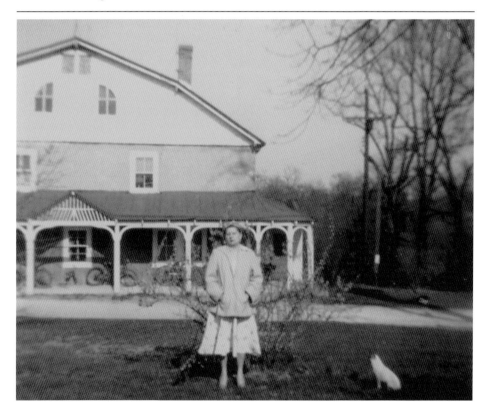

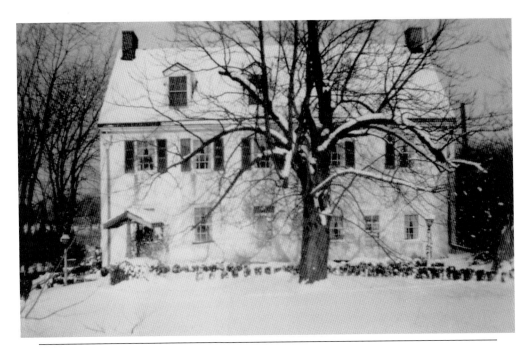

The Thomas Rees house was built around 1745 on land granted to the Rees family by William Penn in 1714. It is an excellent example of an early home built by a well-to-do family, featuring two floors above the main. The town of King of Prussia was originally named Reesville, after this prosperous Welsh family. Like many early homes, it had an addition built to the left side in about 1817, where a grand center stairway, two parlors, and five bedrooms were added. In 1845, the home was owned by John Brooke, who also performed extensive renovations. Brooke owned the King of Prussia Marble Quarry, and his product signaled a change from wood to stone as the building material of choice. The early photograph was taken on Christmas day, 1944. Today it sits empty, without heat or electricity, in need of the same loving care it had come to know from previous owners.

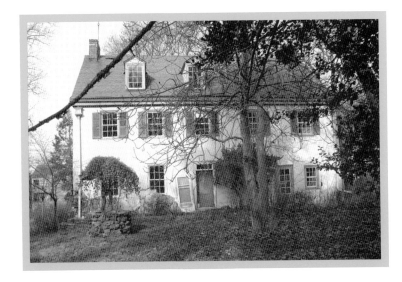

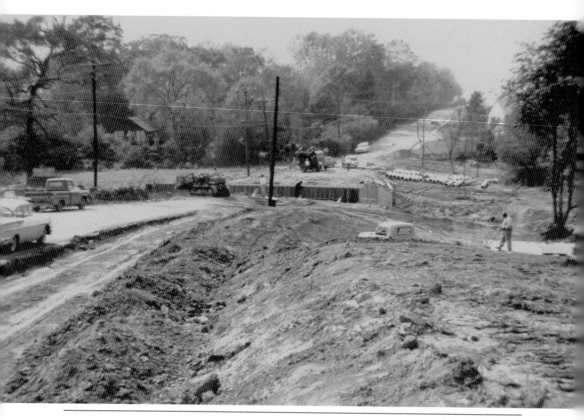

In 1960, the Keebler Road Bridge was constructed to span the Crow Creek. The old bridge was damaged by a storm in 1956. The Crow Creek bisects the town of King of Prussia, although now a good portion runs underground. (Historic image courtesy of David Broida.)

THE CHANGING FACE OF KING OF PRUSSIA

The storm in 1956 did more than damage this bridge, located on Valley Forge Road, requiring it to be replaced completely. The only account of a storm in 1956 was one that occurred on May 21. Although locals refer to it as being a hurricane, available evidence seems to indicate that it was nothing more than a powerful rainstorm. Still, damage to King of Prussia ran into the hundreds of thousands of dollars. (Historic image courtesy of the Loughin family.)

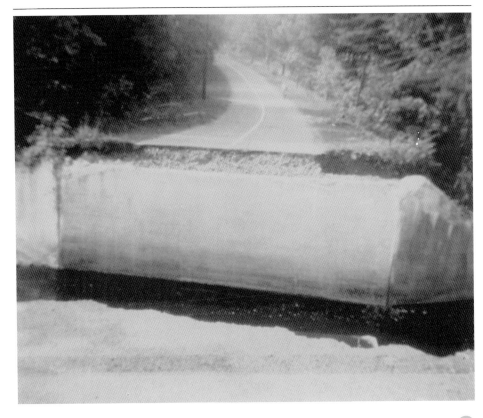

In 1959, the General Electric Space Technology Center was built in King of Prussia. This view from Woodhill Road in the Wayne Woods section shows a wide panorama of rural home sites, about to be changed forever by progress. The George Washington Motor Lodge is visible on the left, and the Pennsylvania Turnpike Interchange 24 can be seen just behind the motor court. By this time, the turnpike no longer ended in King of Prussia, having been continued eastward to New Jersey. Notice the growth in the foliage that has taken place in the nearly 50 years since the early photograph was taken. (Historic image courtesy of Lockheed Martin.)

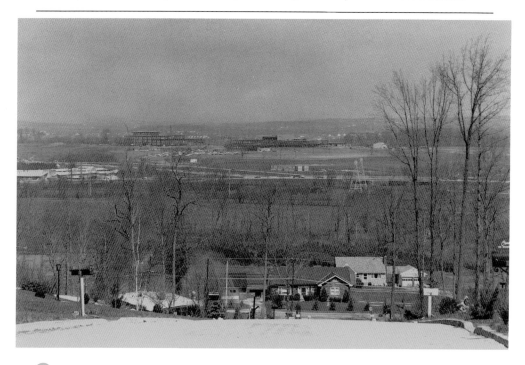

THE CHANGING FACE OF KING OF PRUSSIA

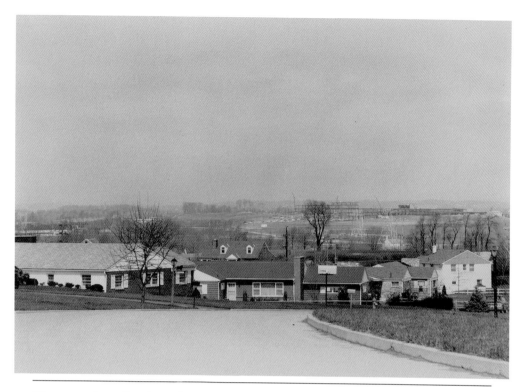

This view from Brookwood Road in the Bob White Farms section shows a slightly different perspective. General Electric built this facility as part of the aerospace division and for the development of military weapons systems, employing hundreds of engineers and retired military personnel. An FBI report stated that during the height of the cold war, King of Prussia ranked third in the nation, just behind Washington, D.C., and New York City, as having the largest number of spies from foreign governments. (Historic image courtesy of Lockheed Martin.)

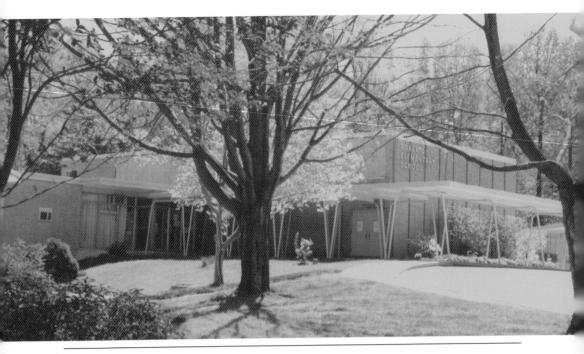

In 1958, Roberts School was built on a 10-acre parcel originally donated to the township by Matthew Roberts. This was the third school to be built on this site, and it stands adjacent to the second, which has been fully restored. This design was used in the Candlebrook and Belmont Schools as well. It was a modern concept and served the community well until the 1990s, when it was determined that new schools were required to fully serve the needs of the children of the community. The design of the new school is aesthetically pleasing and works well with its surroundings. (Historic image courtesy of Patty Volpi.)

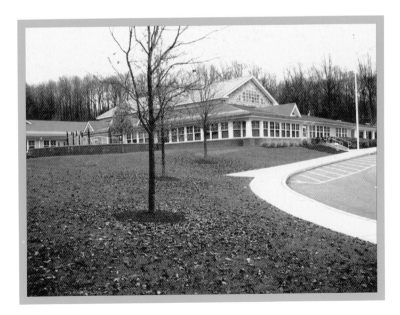

THE CHANGING FACE OF KING OF PRUSSIA

PORT KENNEDY AREA

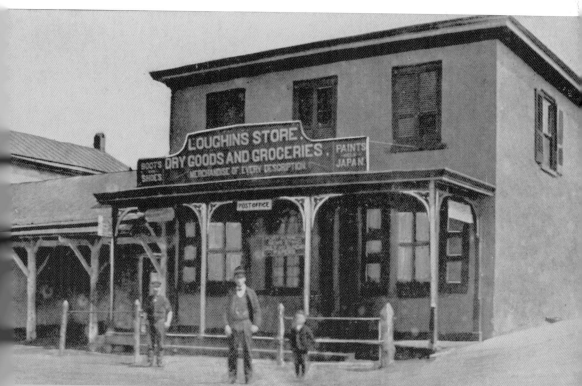

Port Kennedy was one of the earliest industrial villages in the King of Prussia area, located on the eastern portion of the Valley Forge encampment. Named for a prominent family who developed a lime manufacturing business in the early 19th century, it was a thriving community. The Loughin family owned both the hotel and the store, which also served as post office. This photograph appears to have been taken in the mid- to late 1800s. It was one of the last buildings to be removed for highway expansion. (Courtesy of the Loughin family.)

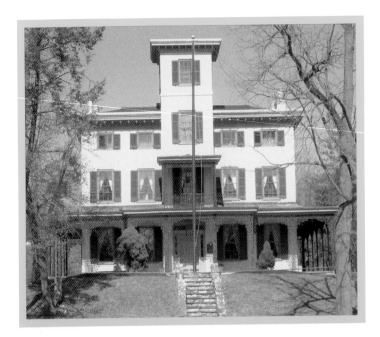

Kenhurst, the home of the Kennedy family, was completed around 1860 and is a marvelous example of Egyptian Revival design. From this location high upon a knoll, John Kennedy could easily observe the daily activity of the bustling community. One of the few remaining buildings in Port Kennedy, it served for many years as a restaurant. Empty now, it still remains in good condition, although the second floor was altered extensively for the HVAC and mechanicals that the restaurant required. (Historic image courtesy of the Library of Congress.)

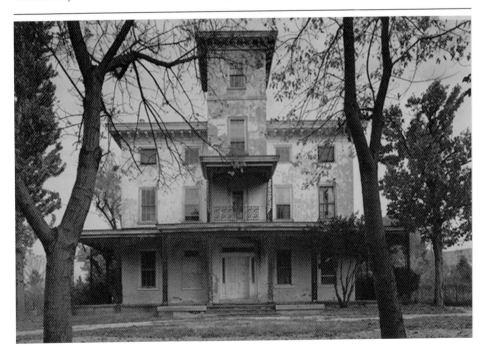

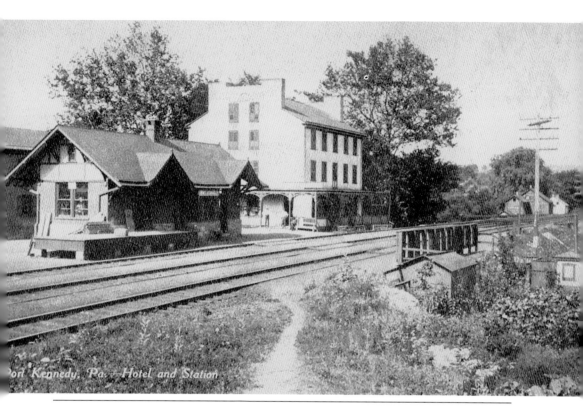

Port Kennedy, Pa.—Hotel and Station

The Philadelphia and Reading Railroad was built in 1835, only 10 years after the Schuylkill Canal was completed. This provided a faster and less-expensive method of moving lime to Philadelphia, and the town flourished. By the beginning of the Civil War, Port Kennedy was the leading producer of lime in the country. Daniel Loughin's three-story hotel can be seen here to the right of the railroad station, which is all that remains.

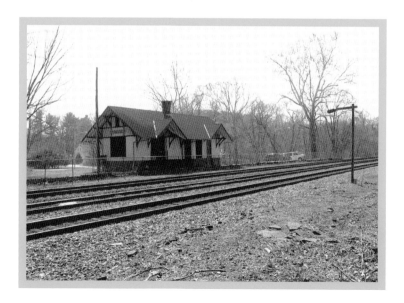

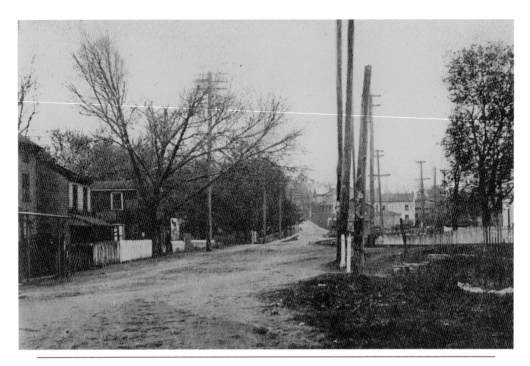

By 1918, there were 118 homes in Port Kennedy, mostly occupied by workers in the quarries. This early view looks southward, along Main Street. By 1919, however, much of Port Kennedy was threatened with condemnation, due to the planned expansion of Valley Forge State Park. By the end of World War I, Port Kennedy was reduced to nothing more than a few houses and a store, run by Hires Garnett. The building of the U.S. 422 highway literally bisected the community, dealing it its final death blow, as many of the remaining houses were removed.

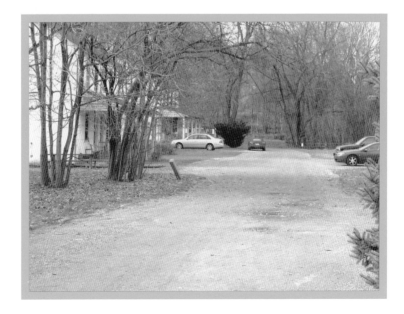

GULPH MILLS AREA

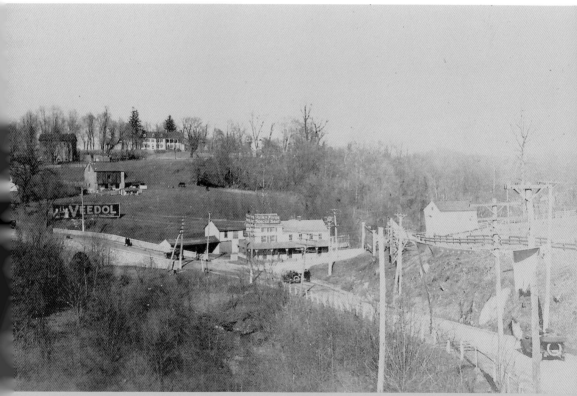

The area known as Gulph Mills grew up around a gristmill built in 1747. The mill supplied flour to the Continental army during its winter encampment at Valley Forge in 1777. This photograph looks down at Gulph Road traversing the picture from left to right, with Balligomingo Road intersecting it just before the bridge. The estate called Varian House can be seen at the top of the hill, and the school is visible just down the hill from it on the left. The photograph was probably taken from the newly completed Philadelphia and Western High-Speed Line (P&W) right-of-way where the first station was built. (Historic image courtesy of the Spragg family.)

This early photograph of the Spragg Store was taken in 1924. Seen here from left to right are George Spragg; his father, William; and his brother Walter. William Spragg came here from England and helped build the P&W. The building operated as the Bird in Hand Hotel in 1900 and was turned into a grocery store when the Spraggs purchased the building in 1920. William's hobby was raising sporting pigeons, and the coop can be seen over the garage on the left. It later became a bar, and Manuel Cigars, Supplee Ice Cream, and C4 gasoline were sold in addition to groceries. C4 was produced in Swedeland, where the SmithKline facility is located today. (Historic image courtesy of the Spragg family.)

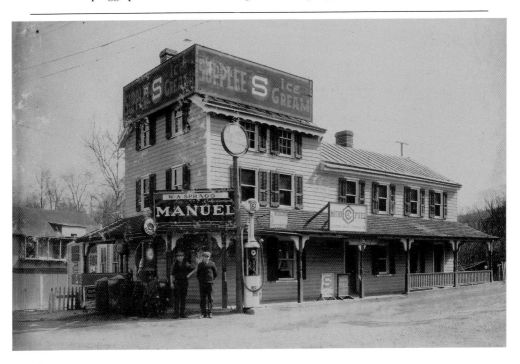

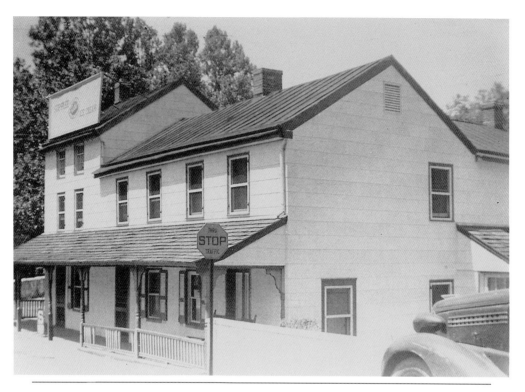

This view from Balligomingo Road shows the Spragg Store in the early 1940s, after some remodeling. During Prohibition, the bar became an ice-cream parlor, and after its repeal, an addition had to be built, as the bar was reopened but could not allow children in to get their ice cream anymore. The building was condemned and razed in 1952, along with many others when the Schuylkill Expressway was built. The store closed in 1941, and the building was sold after William Spragg's death in 1945. (Historic image courtesy of the Spragg family.)

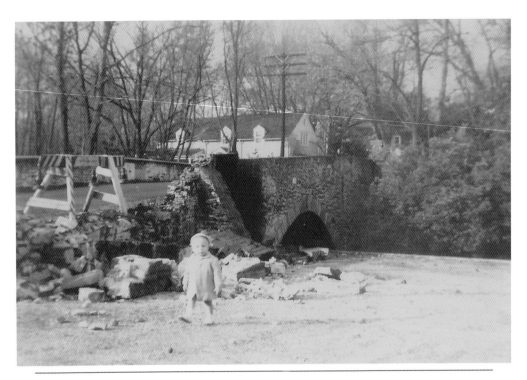

This stone arch bridge over the Gulph Creek on Trinity Lane (formerly Gulph Road) is one of the oldest surviving bridges in Pennsylvania. Gulph Road was originally laid out by William Penn as a westward route from Philadelphia. Its twists and turns are attributed to the local farmers at the time of its creation not wanting the road to cross their land. G. William Spragg is surveying the damage caused by an automobile accident in 1943. Gulph Road was a very busy thoroughfare, and accidents on the bridge were common. (Historic image courtesy of the Spragg family.)

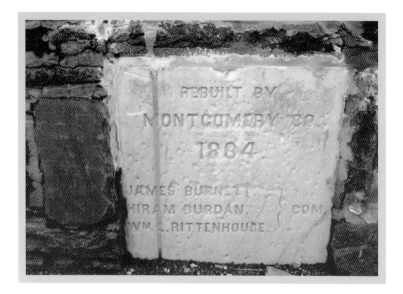

A significant date stone appears on each side of the bridge. The oldest tells of the bridge opening to public traffic in 1789, the second year of the federal union. Notice the misspelling of Upper Merion Township. Major renovations to the bridge also occurred in 1884, where the interior of the arch and its buttresses were made substantially stronger. Further changes to the bridge took place in 1912, when the bridge was made wider to allow for two lanes of traffic to pass.

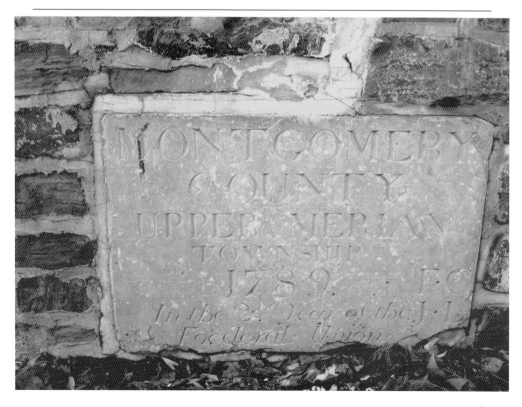

The Upper Merion High School located at the corner of Gulph Road and Henderson Road was built in 1930 and originally housed both elementary and secondary grades. As the population grew, elementary schools were built, and by the 1950s, it was strictly used for junior and senior high school students. A new senior high school was built in 1960, followed by a new junior high school in 1964. Talk of turning the building into a township government facility was rejected, and the building was sold. Fortunately, it has a second life as a successful medical office building. (Historic image courtesy of the Spragg family.)

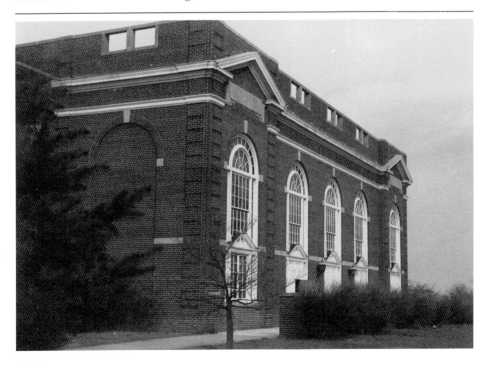

Emma Lou Levering Carson poses at a spring on Shoemaker Lane in this early photograph from 1946. The spring was a good source of water for those living nearby.

Today the spring graces the entrance to the Gulph Mills Village Apartments. (Historic image courtesy of Emma Carson.)

Flash ahead to September 8, 1951, and Emma Lou Levering Carson can be seen on her wedding day, standing in front of the Gulph Mills School and the Gulph Christian Church. The two-room schoolhouse located on Matsonford Road once served as an elementary school while the third Roberts School was being built. It still serves as a private school today. (Historic image courtesy of Emma Carson.)

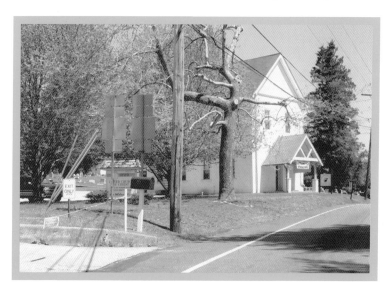

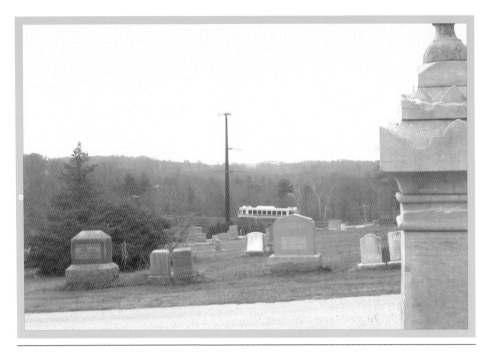

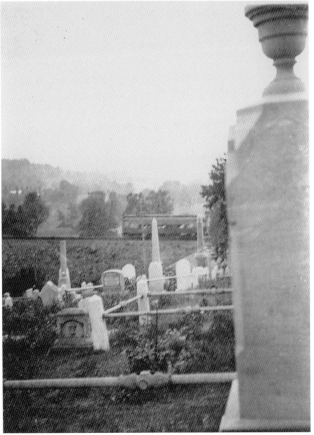

These photographs taken in the cemetery behind the Gulph Christian Church allow for a good vantage point when photographing cars on the P&W. The early photograph shows a Strafford Car, which was used between 1924 and 1927. The newer car is from ABB Traction and took to the rails in 1993. (Historic image courtesy of Emma Carson.)

The southeast boundary of Upper Merion Township can be seen here. The sign welcoming visitors to the township was placed on Gulph Road by a Mobil Oil Service Station. As the story goes, a Mobil Oil executive retired to Florida in the mid-1980s to a small town that did not have a Mobil Oil Service Station. The retired executive was somehow able to trade a franchise with Sunoco, and the stations swapped. The sign was also renewed and relocated slightly. (Historic image courtesy of David Broida.)

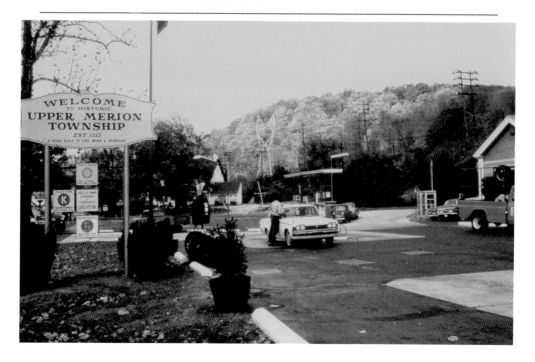

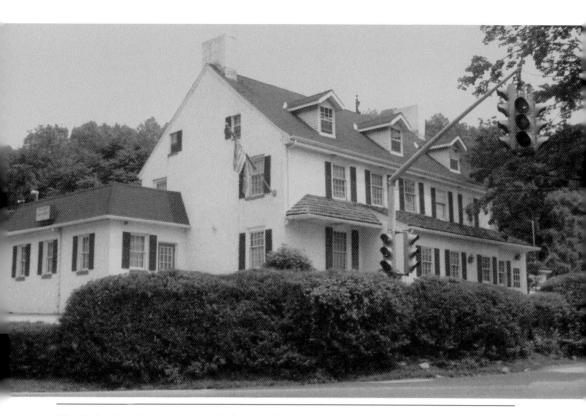

The Picket Post Restaurant on Gulph Road commemorated the building that was once the quarters of Aaron Burr, during the encampment at Valley Forge in the winter of 1777–1778. These quarters represented the farthest outpost from the Continental army, and the closest to the British who occupied Philadelphia. This has always been a good location for a fine restaurant. After the Picket Post closed, it became the short-lived La Tierrra, and now Savona, one of the finest in the area. (Historic image courtesy of David Broida.)

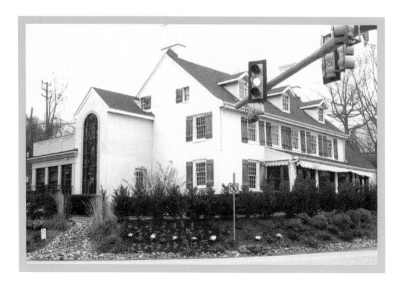

This barn built in 1799 was part of the Samuel Henderson Farm and prosperous stonecutting business. The early photograph was taken in 1941 and shows the excellent stone setting of I. Wright, whose name still appears on the date stone. (Courtesy of the Library of Congress.)

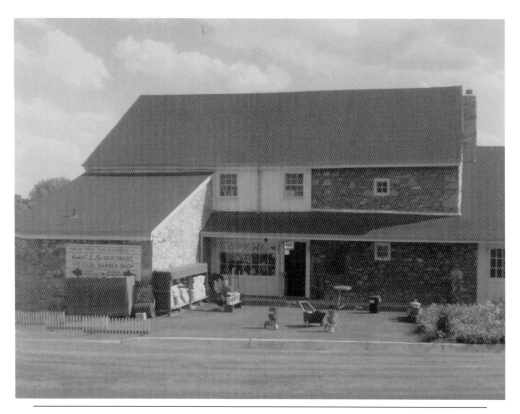

In 1964, a group of enterprising merchants responsible for the first shopping center in King of Prussia converted the barn to a small shopping center. Robert E. Lee's hardware business was located here until his retirement in 1979. Today the Village Mart is still operational as one of the small regional shopping centers spread throughout the township to meet the needs of individual communities. A debt of gratitude is owed to Domenic Pasquale and the original group of merchants who had a vision in 1964 and restored this old original structure, giving it new life. (Historic image courtesy of Bob Lee.)

One must remember that early roads began as one lane, a little more than the width of a wagon or carriage. This photograph of Gulph Road at the iconic Hanging Rock clearly illustrates that point. The first threat to destroy the rock came in 1917, when the Pennsylvania Highway Department proposed a safer and wider highway needed to be built through Gulph Mills. A local group of civic-minded individuals were organized to save the rock due to its historical significance.

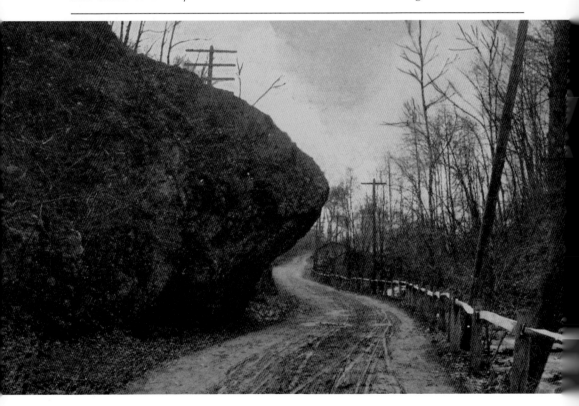

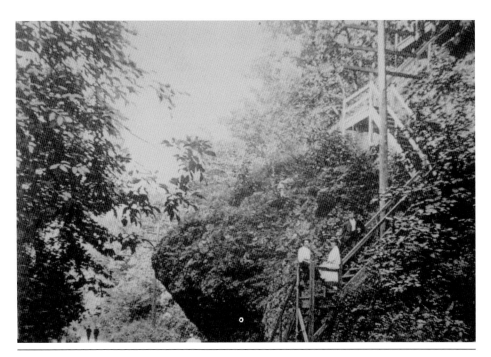

In 1924, Mrs. J. Aubrey Anderson, the owner of the rock, donated it to the Valley Forge Historical Society, hoping that it would be saved as a landmark. A bronze plaque commemorating General Washington's passage by the site with his troops in 1777 was erected, and an agreement to reprofile the rock was reached with highway authorities. The stairs were built for access to a small park at the top of the rock. People would ride the train from Philadelphia and walk to the rock, finding it a lovely destination for an afternoon picnic, until the completion of the P&W. The rock has undergone several reprofilings over the years but will never disappear completely. (Historic image courtesy of David Broida.)

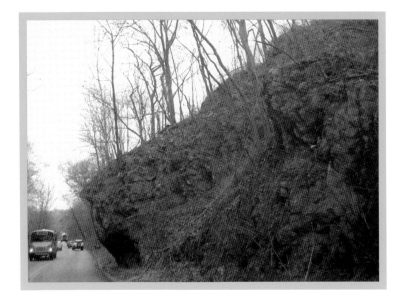

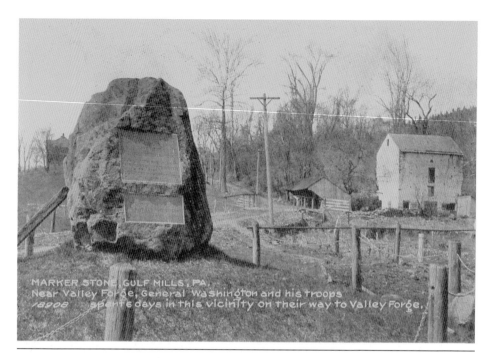

MARKER STONE, GULF MILLS, PA.
Near Valley Forge, General Washington and his troops
18908 spent 6 days in this vicinity on their way to Valley Forge.

The Gulph Mills Memorial is seen here in its original location at the intersection of Gulph Road and Upper Gulph Road, with one of the many mills in the area still visible in the background. It was erected in 1892 by the Pennsylvania Society of the Sons of the Revolution, commemorating the encampment nearby of the Continental army, prior to moving on to Valley Forge in 1777. The nine-foot-tall boulder taken from a hill nearby has been the source of controversy among local residents for many years. It was moved across Upper Gulph Road in 1962 and rededicated. It was later moved to its current location at the Executive Estates Park on nearby Longview Road. Each time it is moved it stirs up resentment among the locals, and protests are not uncommon.

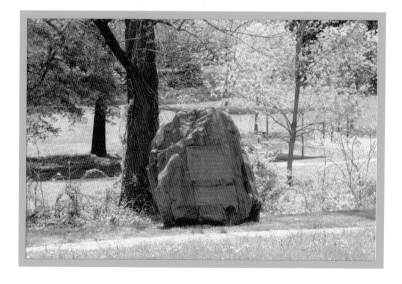

CHAPTER

4

BRIDGEPORT AREA

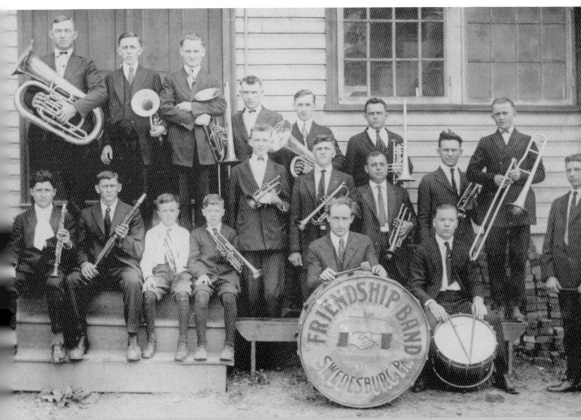

The Friendship Band, organized in Swedesburg, is seen in this photograph from 1920. The villages of Swedesburg and later Swedeland were settled in 1712 by the Swedes, who obtained the land from William Penn. The borough of Bridgeport, a close neighbor to the north, was settled by both the Swedes and the Welsh in 1724 and incorporated in 1851. (Courtesy of Edward Dybicz.)

In Bridgeport, fine little corner restaurants are not uncommon. The Friendship Grill was said to have supplied the uniforms for the band in the photograph on the previous page, in exchange for naming the band after the restaurant. The Friendship Grill was built in 1895 and was in business until 1998, when Frank and Marilyn Gallo renovated the building and opened Anthony's Tavern and Restaurant, serving Italian/American cuisine. (Historic image courtesy of David Broida.)

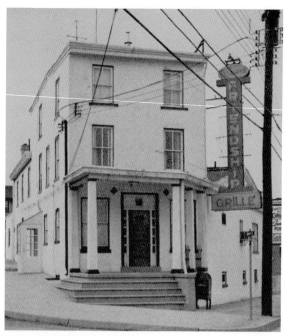

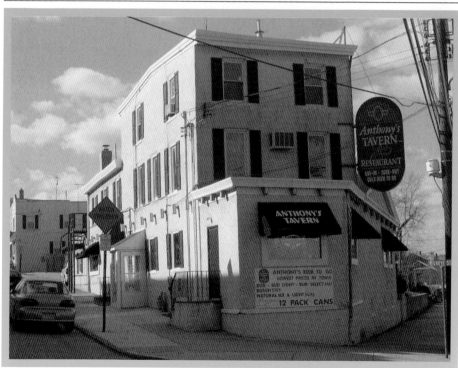

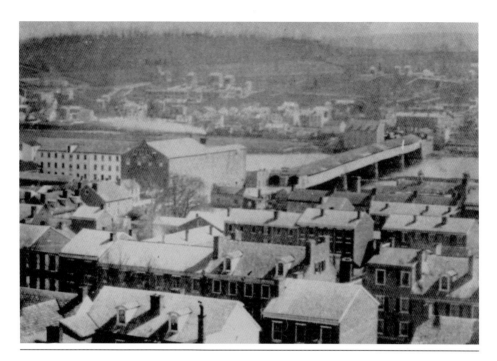

The DeKalb Street Bridge is seen here in this early photograph taken in 1910, as part of a striking panoramic view of Bridgeport and Norristown. Many say that covered bridges were built as a place of shelter for those crossing in bad weather. Others maintain that covering a bridge extends the life of the building materials used in their construction. Today the bridge stands proudly as the DeKalb Veterans Memorial Bridge. The homes in Bridgeport, of which there are over 2,000, are of older construction but very well maintained by its over 4,300 residents. (Historic image courtesy of Edward Dybicz.)

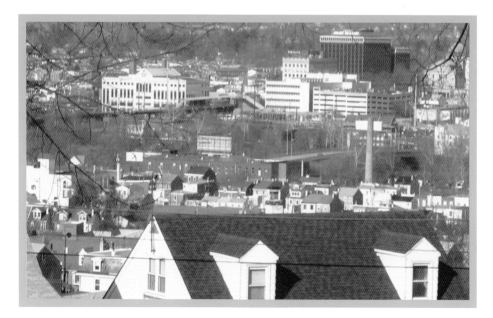

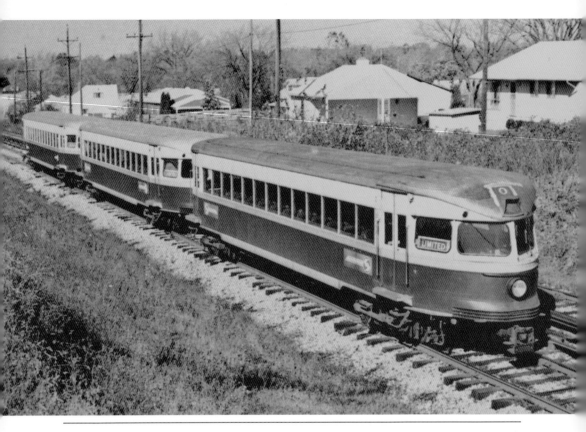

The P&W was built in 1906 and originally ran from Upper Darby to Strafford. The Norristown Branch took a little longer, due to the need for a long metal truss bridge over the Schuylkill River, and was completed in 1912. The original section from Villanova to Strafford was abandoned in 1956 and was recently turned into a hiking trail. The bullet cars, seen here in this early photograph from 1977 in Hughes Park, ran on the line from 1931 until 1990 and were probably the most memorable. They were replaced by the ABB cars in 1993.

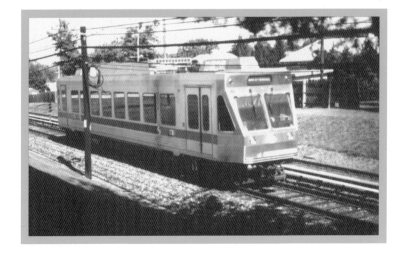

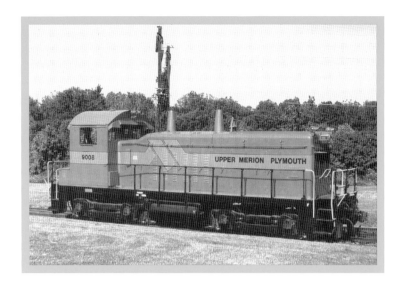

The Upper Merion and Plymouth (UM&P) Railroad Company was created in 1907 and provides rail service to the Bethlehem Steel Corporation's plate mill (formerly Allen Wood) in Conshohocken, Pennsylvania, and to the Philadelphia Inquirer building on River Road. The UM&P tracks follow the Schuylkill River from the plate mill to a connection with Norfolk Southern in Abrams, with much of the inbound steel coming from Coatesville, Pennsylvania. The early locomotive, photographed in 1936, is a Baldwin 0-6-0, built in 1912 in Philadelphia. The later model, painted bright orange and yellow is the No. 9008 NW-2, photographed in 1990 at Ivy Rock, Pennsylvania.

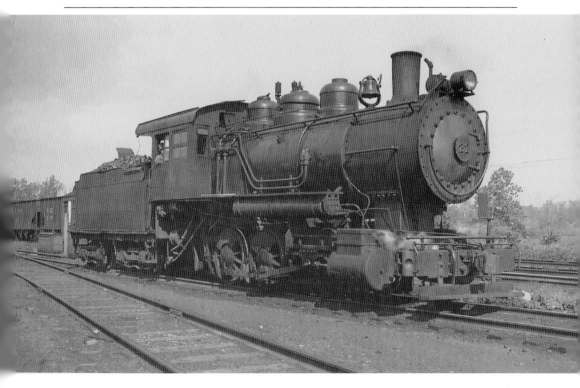

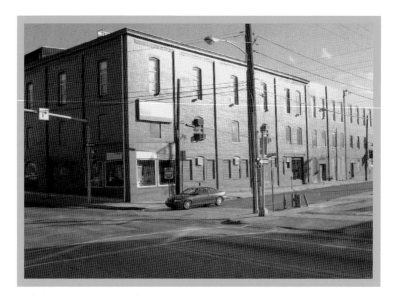

This photograph of the Consolidated Plywood Company located at Front Street and DeKalb Street once served the community as J. B. Horn's Montgomery County Packing, Curing, and Smoking meat processing plant in the late 1890s. Today, as a retail establishment, it still maintains many of its original features, including floors that morbidly slope to the center for drainage. When the DeKalb Street Bridge was closed for repairs several years ago, the enterprising owner painted the entire building bright red as a way of attracting clientele back to his store, as it was then visible from a great distance.

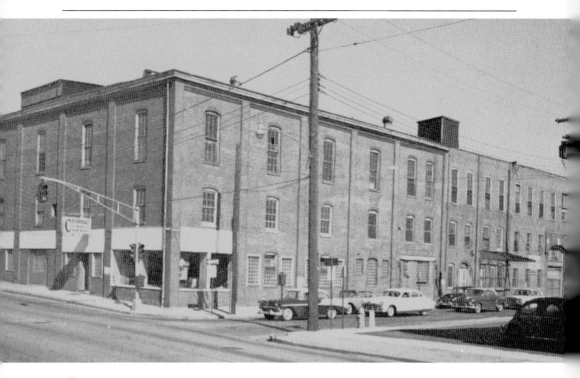

VALLEY FORGE AREA

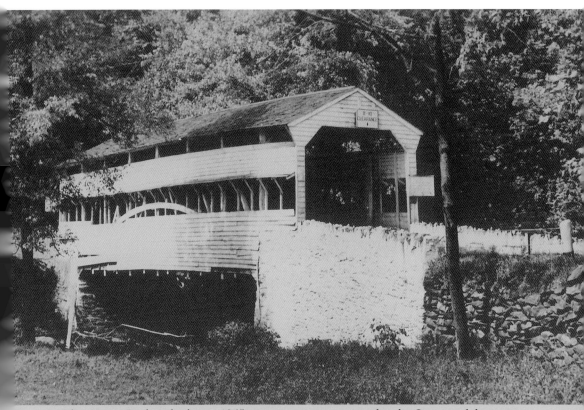

The Knox Bridge, built in 1865, spans the Valley Creek and connects Yellow Springs Road with Valley Forge National Historical Park. It is probably one of the best-known bridges in Pennsylvania due in part to its unusual open design. It uses the Burr Truss design, which is a large arched support on each side. Origins of the name are unclear, as both Gen. Henry Knox and Sen. Philander Knox are said to have been in the running. The bridge has been completely restored since this photograph was taken in the mid-1920s.

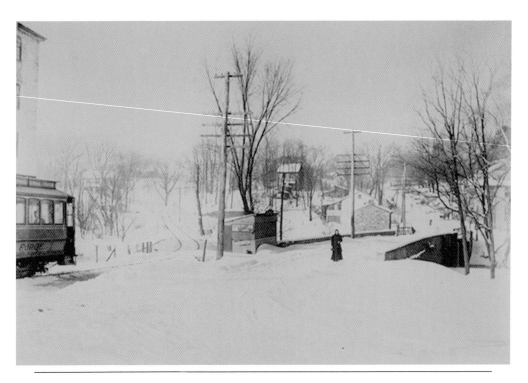

This photograph, taken sometime around 1933, shows a view looking west into Chester County, over the Valley Creek from the area near Washington's headquarters. Interestingly, a trolley line follows the roadway, probably moving workers to and from the Valley Forge Woolen Mill on the left of the road and the Valley Forge Paper Mill on the right. The car, made in Philadelphia, is from the J. G. Brill Company and was widely used through the 1930s. Today the tracks are gone, but Route 23 has changed very little. (Historic image courtesy of the Library of Congress.)

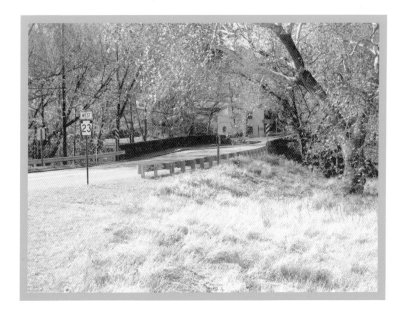

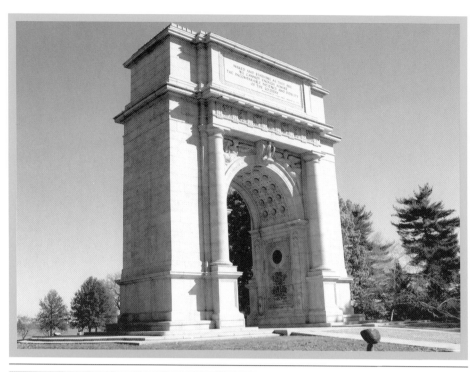

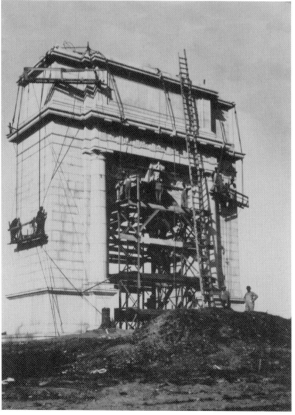

The Valley Forge National Memorial Arch is probably the best-known landmark in Valley Forge. This outstandingly beautiful monument was built in 1910 by authorization of the secretary of war and was given to the Commonwealth of Pennsylvania on June 19, 1917, to commemorate the 139th anniversary of the evacuation of Valley Forge. It was designed by Prof. Paul Philippe Cret of the University of Pennsylvania, and local laborers were hired to complete the job. It reverently faces what once was Gulph Road, the route used by the Continental army as it passed by and dispersed to winter over in 1777–1778.

It is clear by these photographs taken nearly 100 years apart, that America will not let a national treasure fall into disrepair. Washington's headquarters was established shortly after the general's arrival to Valley Forge, as a place to organize plans for the Continental army, and as a place to receive foreign dignitaries. The house was rented from its owner, Isaac Potts, in the area of a great iron forge, built in the 1740s. It remains largely untouched, and is a perfectly restored time capsule as to life in early Colonial times. An interesting footnote is that the commanding general's home was always termed the "headquarters," while all other officers stayed in "quarters."

Beside Washington's headquarters stands a stable where the general's horse was kept. It was rumored that during an excavation in the 1940s, a tunnel was found there leading in the direction of the Schuylkill River, less than 100 yards away. It was thought that this tunnel would have provided the general with a means of escape, although this speculation has never been verified and is flatly denied by national park personnel. The stable remains in excellent condition as an integral part of the headquarters complex.

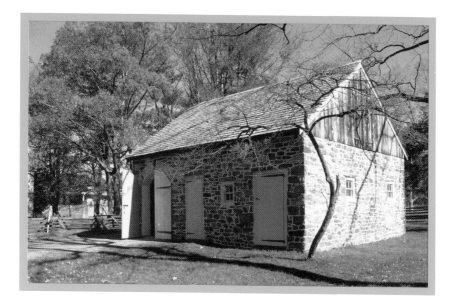

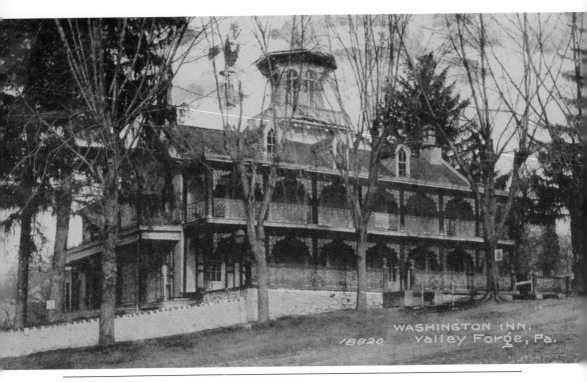

This house has been many things, but the National Park Service has yet to uncover any real evidence that it was used for military purposes during the encampment of 1777–1778. Speculation was that the house did triple duty during the encampment. The court marshal room was on the main floor, bread for hungry Continental troops was baked in the basement, and its owner, Col. William Dewees, lived with his family on the second floor. The first real evidence of ownership comes in the 1780s, when Daniel Potts added a wing and staircase to the existing structure and moved in with his family. The Potts house passed on to several owners, virtually unchanged until 1854, when businessman Charles Rodgers converted the house to a Victorian villa complete with a two-story front porch, intricate ironwork, and cupola.

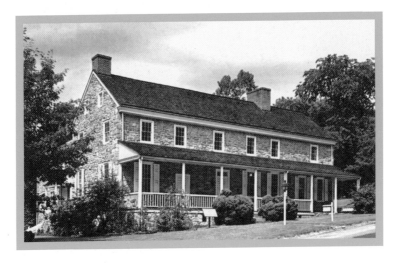

VALLEY FORGE AREA

Another view of the Washington Inn gives an excellent perspective of life in the early 20th century. As industry faded, tourism flourished and Sarah Shaw began operations in 1868 at the Washington Inn. The inn finally closed in 1942, and the Valley Forge Park Commission acquired the property, restoring it to its 1780s appearance. Today the view is somewhat obscured by foliage but has been well cared for over the years. It is one of over 130 vacant buildings in Valley Forge National Historical Park at the time of this writing.

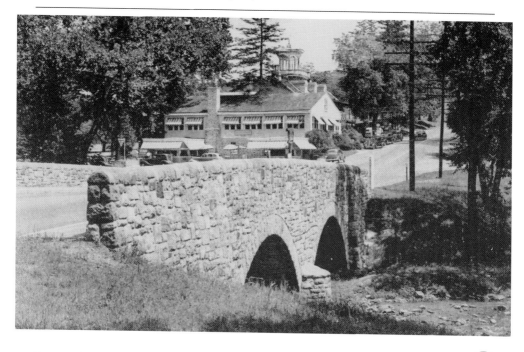

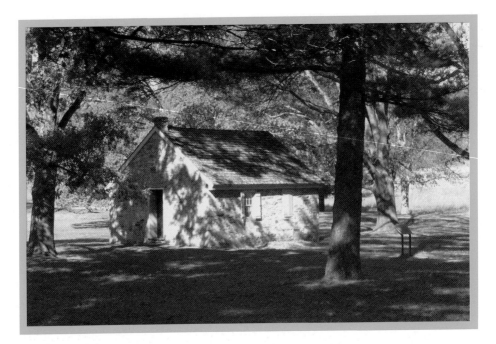

William Penn gave his daughter Letitia a large tract of land called Mount Joy, on which Valley Forge National Historical Park stands today. She is also credited with building a school in 1705. Originally restored in 1907, the school served the children of settlers who purchased land from Letita and built their homes nearby. Note the maturity of the foliage in the later photograph, taken nearly 100 years after the original.

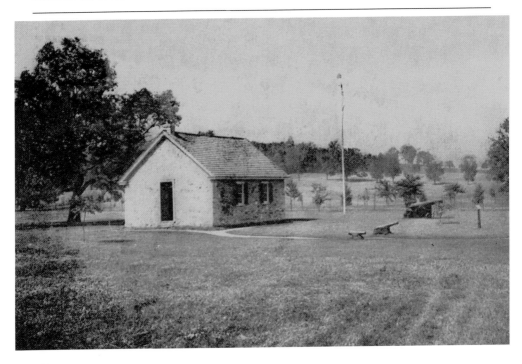

With the advent of the automobile, Valley Forge became a tourist destination. The school was a favorite place for photographs, due to its easy access from the highway. The "Camp School" was said to have served as a hospital during the winter of 1777–1778, but like many other stories to come out of that period, there is no evidence to support it being anything other than a school.

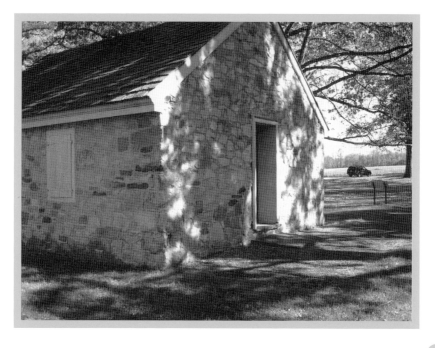

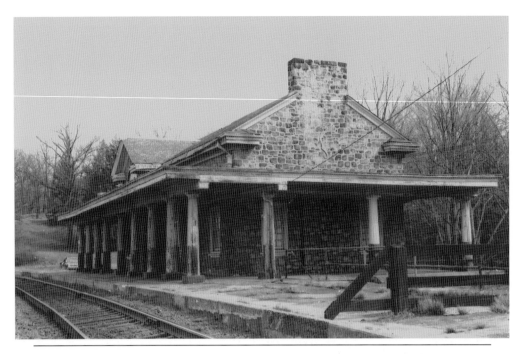

By 1838, the Philadelphia and Reading Railroad began construction on a 94-mile project from the Reading terminal in Philadelphia through Manayunk, Gladwyne, West Conshohocken, Bridgeport, Valley Forge, Phoenixville, Royersford, Pottstown, Reading, and on to Pottsville. It continued with passenger and freight service until 1985. This station in Valley Forge was a popular destination for tourists, but even before the line closed, the station fell into disrepair. The early photograph was taken in 1973 and shows the condition of the station just prior to its renovation for the bicentennial. There is talk of re-creating the regional passenger rail system as a way of easing the congestion of automobile traffic in the area, but funding has not yet been appropriated.

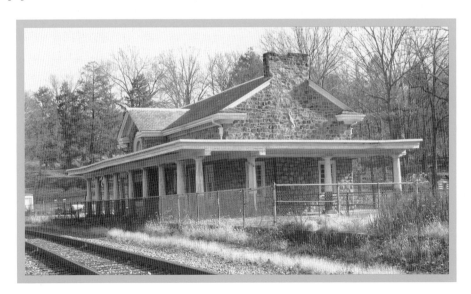

VIEWS FROM ABOVE

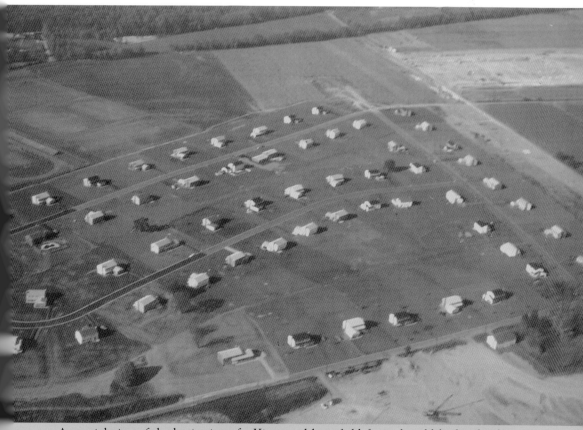

An aerial view of the beginning of a King of Prussia neighborhood can be seen here. The roads are Crooked Lane, School Line Drive, Edgewood Road, and so on. The athletic field from the old high school at the corner of Gulph Road and Henderson Road helps to pinpoint this location. (Historic image courtesy of David Broida.)

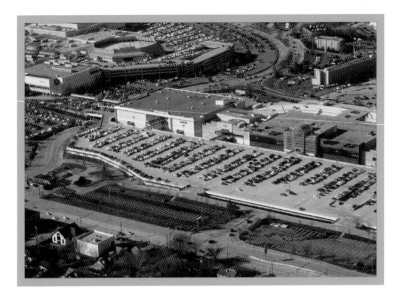

This early view from the sky shows the heart of King of Prussia just prior to big changes to begin in the mid-1980s. The King of Prussia Plaza is visible in the center of the photograph prior to expansion, with then Goddard Boulevard wrapping around its perimeter. The General Electric Space Technology Center is partially visible at the top, and U.S. 202 can be seen at the bottom, with most of the original center of town still intact. Many of the places discussed earlier can be seen here. The later photograph shows how dramatically things have changed in the approximately 20 years that have elapsed between these photographs. (Historic image courtesy of David Broida.)

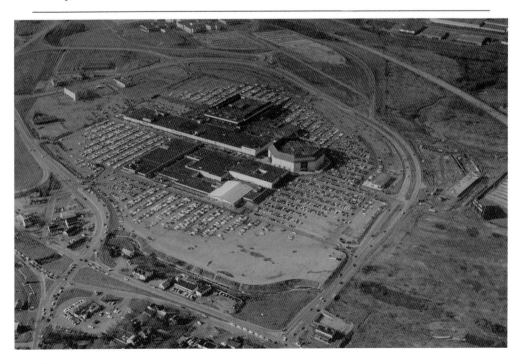

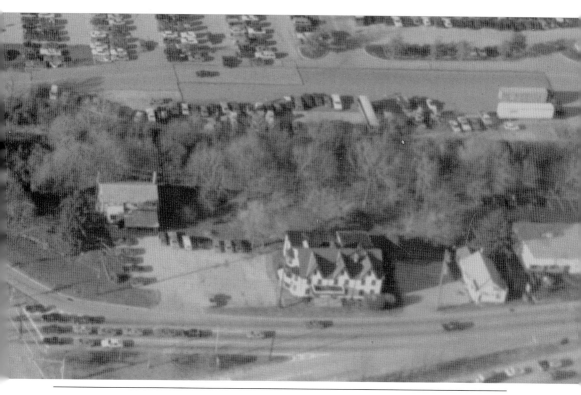

Another view from above shows the gabled roof of the former home of the Royer-Greaves School for Blind and later a boardinghouse run by Jean Supplee. To its left is the carriage house that also served as the first firehouse, a Pepperidge Farm Thrift Store, and later a more notorious incarnation. Clearly the expansion of the mall and the need for more lanes of highway had to come from somewhere, and that "somewhere" was from the historic buildings that lined the street. (Historic image courtesy of David Broida.)

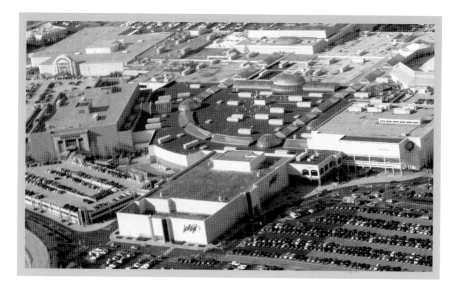

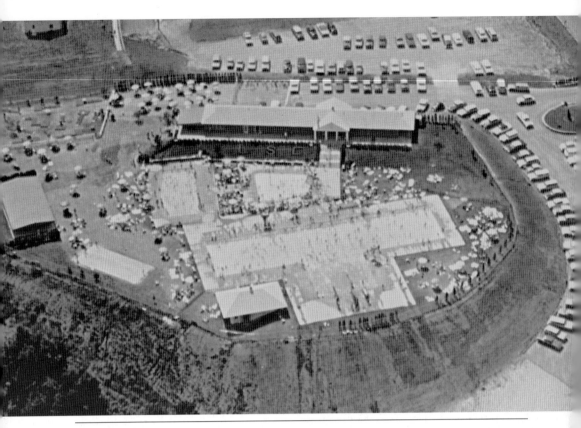

Summertime in King of Prussia in the 1960s offered a variety of activities centered around the water. Colonial Village Swim Club, Martin's Dam, Upper Merion, and of course Lafayette Swim Club, pictured here, were a summer oasis for children. One by one, the clubs began to disappear. One became a housing development, one was closed because it was built on a toxic waste site, and in the case of Lafayette Swim Club, it was sold to a Gold's Gym franchise. The gym facility can be seen in the more recent photograph, and although the swim club facility is still there, it is no longer open to the public. It was a sad day when it closed its doors forever.

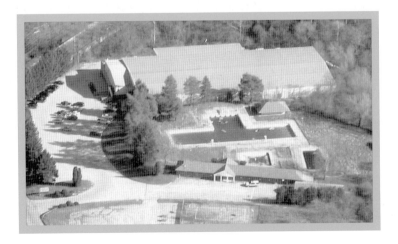

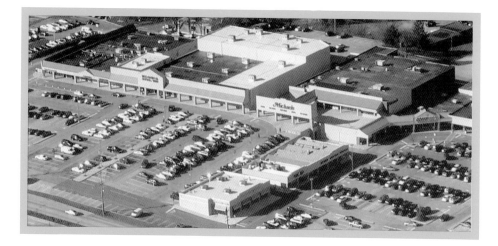

The year was 1969. *Midnight Cowboy* was playing at the King Theatre, Victoria Station was yet to be built on the vacant lot to the right, Queen TV and Appliances still occupied its original store, and Food Fair was a busy supermarket at the Valley Forge Shopping Center. Some 37 years later there have been face-lifts to the facades and the retail mix has changed considerably. (Historic image courtesy of David Broida.)

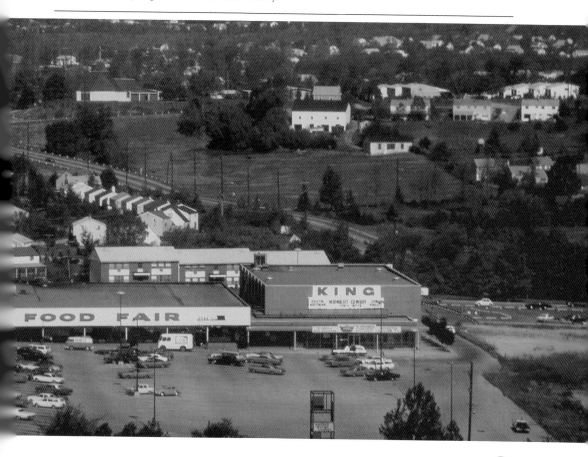

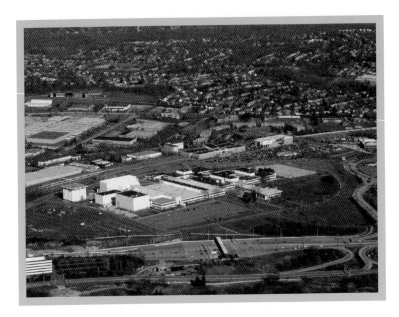

This view of the General Electric Space Technology Center, now owned by Lockheed Martin, shows some expansion to the facility, but the footprint remains similar. More striking are the changes around the perimeter of the facility. Notice the growth to the industrial park in the background, the Pennsylvania Turnpike Interchange in the foreground, and the death of a golf course at the bottom of the picture. (Historic image courtesy of David Broida.)

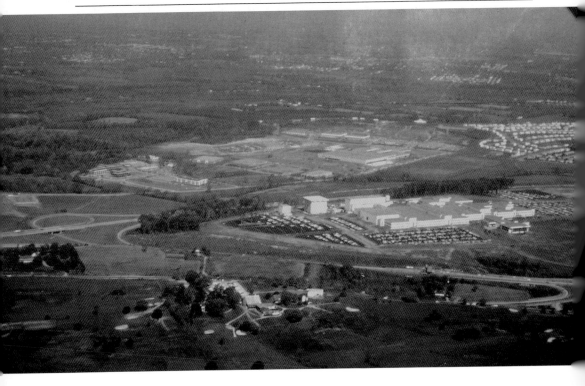

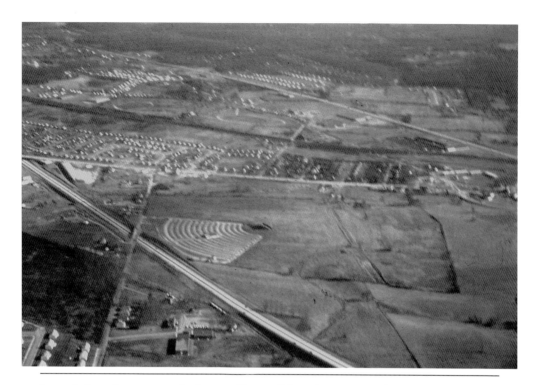

Long before the court and plaza at King of Prussia was built on what was Wilson's Maplecroft Dairy Farm, there was the Valley Forge Drive-In Theatre located on what was once the Anderson Farm on Allendale Road. Like its counterparts in Devon, Exton, Limerick, and on Ridge Pike, they occupied some very valuable land. One by one, they were replaced by more profitable venues. In the case of King of Prussia, the drive-in was replaced by stores like Costco and the newly renovated Crowne Plaza. (Historic image courtesy of David Broida.)

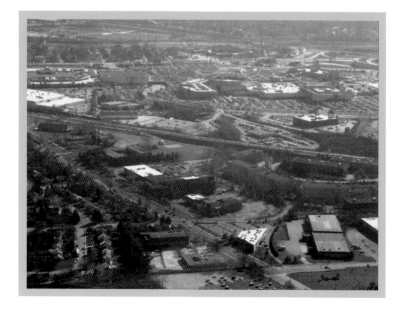

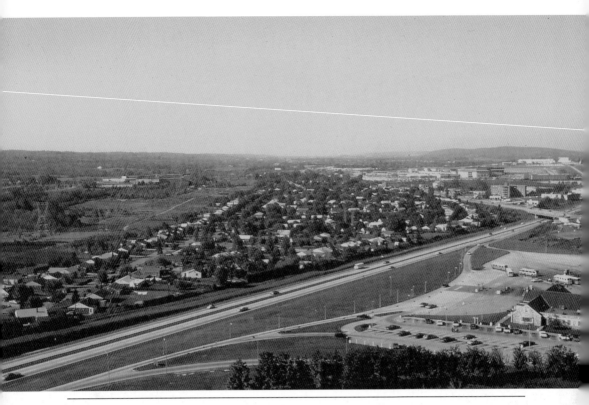

This aerial view shows the Pennsylvania Turnpike, highlighting the King of Prussia Service Plazas on the westbound side. There are 21 service plazas along the highway that extends over 340 miles across the state. They were originally run by Howard Johnson's and featured Gulf gasoline. (Historic image courtesy of David Broida.)

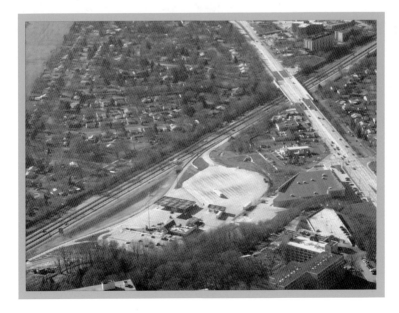

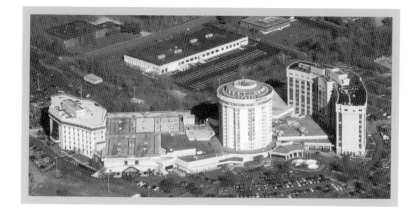

The Sheraton Valley Forge Resort Hotel, now the Radisson Valley Forge, has always been shadowed in controversy. In June 1952, shortly before completion, the hotel was assaulted by union workers and set ablaze to protest its construction by non-union workers. When a second tower was proposed, neighbors were up in arms, worried about the additional light the building would cast. There would even be a problem trying to get a sign on the roof. Through it all, the property has maintained itself well, and a new facelift promises a seamless transition into this new century.

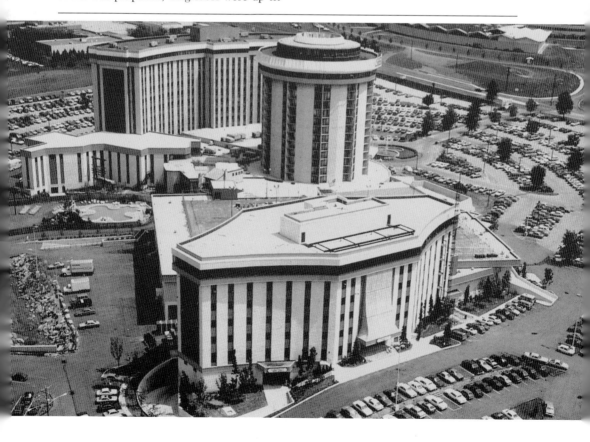

ACROSS AMERICA, PEOPLE ARE DISCOVERING SOMETHING WONDERFUL. *THEIR HERITAGE.*

Arcadia Publishing is the leading local history publisher in the United States. With more than 3,000 titles in print and hundreds of new titles released every year, Arcadia has extensive specialized experience chronicling the history of communities and celebrating America's hidden stories, bringing to life the people, places, and events from the past. To discover the history of other communities across the nation, please visit:

www.arcadiapublishing.com

Customized search tools allow you to find regional history books about the town where you grew up, the cities where your friends and family live, the town where your parents met, or even that retirement spot you've been dreaming about.